The Rise of the Artist

LIBRARY OF MEDIEVAL CIVILIZATION
EDITED BY JOAN EVANS AND
PROFESSOR CHRISTOPHER BROOKE

ANDREW MARTINDALE

The Rise of the Artist

IN THE MIDDLE AGES
AND EARLY RENAISSANCE

McGRAW–HILL BOOK COMPANY · NEW YORK

The drawing on the title-page is from a thirteenth-
century French pattern-book, and shows a mural
painter and an illuminator at work. Österreichische
Nationalbibliothek, Vienna.

Contents

General Editor's Preface

In 1966 a large and handsome book was published by Messrs Thames and Hudson, with the title *The Flowering of the Middle Ages*. The text was provided by a team of scholars under the shrewd and skilful captaincy of Joan Evans, and could be read with pleasure and profit by all those who could afford to buy the book, and had an ample lectern on which to lay it. Word has come to the publishers that there are many who have smaller pockets and less ambitious furniture, who would like none the less to read its chapters as well as to admire the *Flowering's* illustrations. They therefore asked me to join with Dr Evans in the pleasant task of converting the book into a series of small volumes, each incorporating a chapter of the original. The old chapters have been roused, stretched and shaken into a new and somewhat enlarged shape, have donned their old costume of pictures considerably increased, and now present themselves to the public for inspection.

CHRISTOPHER BROOKE

Acknowledgment

We wish to make warm acknowledgment on behalf of the publisher and the editors to the help derived from Mrs Virginia Wylie Egbert's *Mediaeval Artist at Work* (Princeton University Press, 1967) in the preparation of plates and of captions for *The Flowering of the Middle Ages*, and for *The Rise of the Artist*; and to draw the attention of readers to Mrs Egbert's interesting study of a parallel theme. This help was noted in the reprint of *Flowering* (1967), but not, to our deep regret, in the *Flowering* as originally published, since it was not at that time known to us or to the author of this book, Andrew Martindale. He has asked to be associated with us in this acknowledgment.

JOAN EVANS
CHRISTOPHER BROOKE

6

Foreword
to the Original Edition

Fifty years ago history was mainly studied in school and university, and as a consequence by the educated reader, in terms of wars, political alliances and constitutional developments. Its base was properly in written documents, and even social history was not envisaged in other than documentary terms. Eight half-tone illustrations were enough for any historical work and most were not illustrated at all.

Now, at least for the general reader, all is changed. Schoolmasters attempt to give some visual background to their history lessons; occasionally even a professor of history may show a few slides. Professional historians and archivists rightly continue to study every facet of their subject in documented detail, but for most people 'history' has become a much more general matter, that provides them with a background to what they see and what they read. For them, at least, historians must so interpret the documents as to make them reveal the life of the past rather than its battles and its political machinations.

This change is due less to the professional historians themselves than to a change of view in the reading public: a change that can only be paralleled in the second half of the nineteenth century when trains and steamers made it easy to travel and everyone began to know their Europe. That time produced its Ruskin and its Viollet-le-Duc, its Lasteyrie and its Henry Adams; but we forget that Ruskin had to draw, or to engage others to draw for him, the things he wrote and talked about, and that Viollet-le-Duc was never able to reproduce a photograph.

In our own day a new wave of travel by car and plane has been accompanied by incredible developments in photography and in reproduction. Black and white photographs and half-tone blocks revolutionized the study of architecture and art at the end of the nineteenth century, and the great archaeological discoveries of the

day made the general public willing to accept an object or a building *pari passu* with a written document. In our own time colour photographs and colour plates have enriched these studies in a way that would have seemed miraculous to Ruskin.

Moreover, though education remains astonishingly bookish, our recreations have trained our eyes. An experienced and successful lecturer of 1900 said that a slide must remain on the screen for at least a minute to give the audience time to take it in. Now, the cinema screen and the television set have trained us in visual nimbleness, and we 'see' much more quickly. . . .

Somewhere about 1100 it seems as if Europe settled on an even keel. In England the Norman dynasty had established itself militarily and administratively. In France Philip I had established a rival kingdom, the Cluniac reform had revivified religious life, and the Crusades had started on their way. In Germany Henry IV was establishing the Empire on a firmer basis. In Italy Pope Gregory VII had lost his fight against the Emperor, but had gained new spiritual force for Rome. In Spain Alfonso VI of Castile had made Toledo the capital of Christian Spain, and the Cid had conquered Valencia. In the Eastern Empire the Comneni had suffered the inroads first of the Normans and then of the Crusaders; the weight of power was shifting westward. In Europe it is fair to say that a measure of stability had been achieved, in which the forces of feudalism, monasticism, scholastic philosophy and civic growth could work together to make the history of the Middle Ages.

To make that history more real to the ordinary reader is our purpose. The authors have not here published unknown documents, unknown monuments or unknown works of art, but have tried by the interpretation of what is known to make the Christian civilization of Europe in the Middle Ages more significant and more comprehensible to the readers of today. The keyword to our conception of history is civilization.

JOAN EVANS

The Artist in Town and City

It is usual to write the history of art as it were from the top downwards. If, however, one wishes to build up a balanced picture of the artist in medieval society, one cannot ignore the lower echelons of those producing art. Before the fifteenth century there is no evidence for any of the *mystique* which has since grown up around the Great Artist. Good artists were almost certainly regarded as superior craftsmen in a particular occupation; and any investigation of the place of the artist in society must take this attitude as a starting-point. The artist was in the first place a craftsman, working perhaps in some busy, cosmopolitan centre where any one craftsman had to live alongside many other people practising different crafts or trades. From this point of view, almost any large medieval town would serve as a point of departure; and if our choice falls on Paris, this is chiefly on account of the convenient documentation. *1*

In 1323 the French scholar Jean de Jandun wrote a treatise in praise of Paris. One chapter is headed 'Concerning the Manual Artificers', and it represents an educated man listing, in rather elaborate Latin, those crafts which he felt were an ornament to the city:

> We have also thought to add something concerning those craftsmen working with their hands, if it will not displease the reader to consider them. Here indeed you will find the most ingenious makers of all sorts of image, whether contrived in sculpture or *8*
> in painting or in relief. Here too you will see the most cunning *5, 7*
> constructors of instruments of war. . . . Again, you will discover men preparing most diligently clothing and ornaments.
> We are not ashamed to mention here the makers of bread . . .
> nor yet the fashioners of metal vessels. . . . The more intently the *1, 6, 24*
> parchment-makers, scribes, illuminators and bookbinders devote *2, 21*
> themselves in the service of wisdom to the decoration of their

9

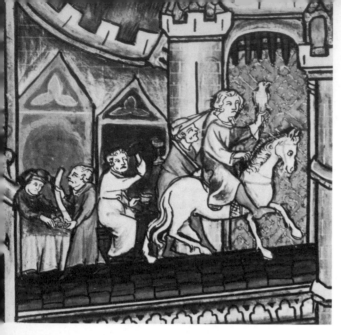

1 Paris, like other capital cities, had its colonies of artists and craftsmen, usually congregated in districts according to their trade. Here a goldsmith of the early fourteenth century is seen through his open door from the street, at work on a cup. In front of him, on a shelf, stands one already finished

works, the more copiously do the delightful fountains of knowledge flow forth from that most profound source of all good things.

This is a strange and apparently disjointed list. It clearly did not appear inappropriate to Jandun that the painters should be praised almost in the same breath as the Parisian bread-shops; nor that in this short chapter, those supplying books to the University should rub shoulders with the armament or clothing manufacturers.

This general picture of the artist as one craftsman among many can be elaborated into something far more precise from the Parisian taxation lists. The earliest surviving list, which dates from 1292 and is therefore not very long before Jandun's description, gives a much more detailed picture of the artist working in a community. The number of declared artists was small. In 1292 there were nearly 15,200 taxpayers in Paris. Of these, only 33 said they were 'painters'; 24 said they were 'image-makers' and 13 'illuminators'. Understandably, most tradesmen and craftsmen made their living by providing the necessities of life. Over 350 made shoes, over 350 were concerned in the making of clothing. There were 214 furriers; 104 made *patisseries* and sweetmeats; 157 kept eating-houses and taverns; 120 were grocers.

Against each person in these lists is written his assessment for tax. Most medieval taxation of this variety was levied on an agreed valuation of a man's movable goods so that, although the key to the exact significance of these figures may now be lost, the individual amounts, taken collectively, should provide a sort of comparative table of opulence (or at least of *signes extérieurs de richesse*).

As occupations went, painting and image-making did not apparently open up vistas of immense wealth. The richest Parisians were, of course, the Lombard bankers and financiers. Amongst those, the highest individual tax liability was 114 *livres* 10 *sous*. Amongst tradesmen and craftsmen the most highly taxed (and therefore the most well-to-do) were two potters (19*l* and 7*l* 10*s*), two merchants of precious and semi-precious stones (10*l* and 7*l* 10*s*), two mercers (16*l* and 8*l*), and a considerable number of others paying between 5*l* and 10*l* tax. Only one painter (called Nicholas) reached this class (6*l*). Only two painters and one image-maker paid more than 1*l* tax, the majority paid 10*s* or less. About only one of the listed artists is anything definite known – that is, Master 3, 11 Honoré, the manuscript-illuminator. He was the most distinguished book-illuminator in Paris of the time. Some of the books which he produced for the royal court still survive, and by any standards he was an artist of great skill and technical mastery. Master Honoré, however, paid only 10*s* tax, which means that, unless he was practising tax evasion on some scale (there is, incidentally, no reason to suppose this), the property on which the tax was assessed cannot have been worth an enormous amount. Master Honoré was probably comfortably off since he possessed a servant. But, to judge from this general scale of taxation, only the one painter Nicholas would probably have been thought rich.

Trades and crafts in medieval towns tended to congregate in communities. This, too, is illustrated by these lists, which were drawn up by parishes and streets. Most of those people in Paris concerned in book production, including the majority of the manuscript-illuminators, lived on the south bank, in the vicinity of the University. On the other hand most of the painters and image-makers lived on the north bank, particularly in the three parishes of Saint-Germain-l'Auxerrois, Saint-Leu and Saint-Eustache which were at that date on the north-west perimeter of the city. But in fact there was a sprinkling of these trades throughout

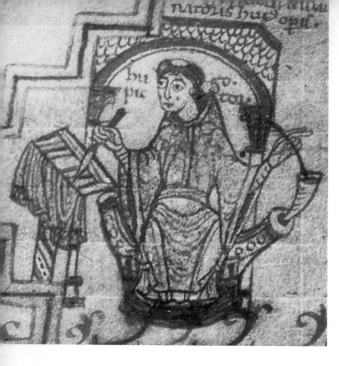

2 *Left:* 'Hugo pictor' – Hugh the painter, from a manuscript of about 1100. Hugo, in monk's habit, dips a pen into an inkhorn with one hand and in the other holds a knife to sharpen the quill

3 *Right:* a manuscript illuminated by Master Honoré, about whose life and working conditions a surprising amount is known. The painting, from Gratian's *Decretals*, of before 1288, shows a king dictating the law

the city on the north bank. The painter Nicholas lived apart in the parish of Saint-Jean-en-Grève – a parish, it may be noted, which also contained the wealthiest scribe and two of the wealthiest masons.

Most medieval trades and crafts were organized on a guild basis within each city. Painters and sculptors were no exception. Many of the guild ordinances survive and, since the general aims of these associations were similar, it is not surprising that these separate sets of ordinances should have features in common. By the fourteenth century the principal aims of a guild were to protect the local craftsmen from unreasonable outside competition, to protect the local craftsmen from each other and to safeguard the quality of work produced by the members. To these protective measures were sometimes added charitable ones: enjoining the visitation of the sick and indigent members by those more fortunate, and also ensuring that members' funerals should be well attended. This last provision was prompted as much by *esprit de corps* as by any finer feeling of grief. It would have been unfitting that a member should go to his grave unmourned and without ceremony. Sometimes *esprit de corps* prompted further measures. The ordinances of the

12

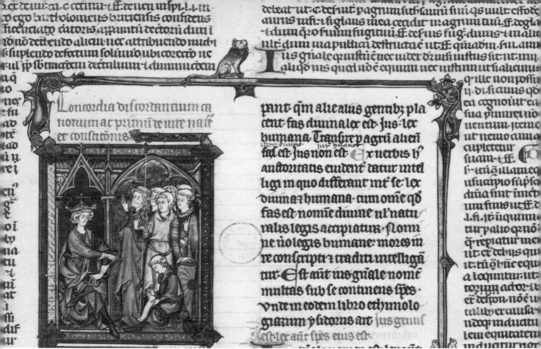

painters' guild of Siena, for instance, went to extraordinary lengths to ensure that the annual service on the Festival of St Luke (the patron saint of artists) should be properly attended by the whole body of painters and apprentices, each bearing a candle. The festival arrangements, it was decreed in 1355, were to be made at a general meeting held eight days previously. An amendment of 1357 added that non-attendance at this meeting was no excuse for not turning up for the festival. A further amendment of 1361 added that, in the event of absence from Siena, a painter still had to ensure the presence of a representative bearing a candle. An addition approved in 1367 instituted a special fine for those complaining against the arrangements for St Luke's Feast, and a further addition approved in 1402 stated, in passing, that illness was no excuse for not being represented by a proxy. In an age in which actual appearances counted for so much, the heads of the guilds were, it seems, anxious that the painters should 'put up a good show' on the feast of their saint.

12, 13

The various guild ordinances are also of interest because they provide information about what the artists did. It is at this point perhaps that the stature of an artist in the Middle Ages becomes

13

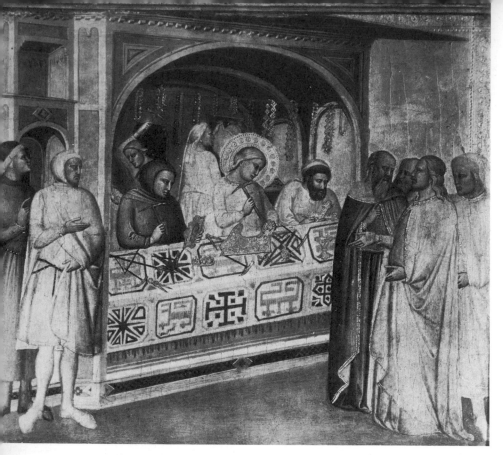

4 Among the tasks demanded of an artist was the painting of saddles. St Eligius, the patron saint of goldsmiths, is here seen making the gold covering of a saddle. Other samples of work lie on the counter

particularly hard to understand, and it may be easiest to consider painting and sculpture separately.

The earliest ordinances (1283) of the London painters' guild contain only nine clauses. Of these, the first four (which are the only clauses relating to any specific type of work) are concerned with the painting of saddles. The first clause forbids the patching-up and painting of saddles which were unsound. This was perhaps the equivalent to respraying a defective motor-car which, while appearing to be new, might later fall to pieces at some crucial moment. What is important here, however, is that this may seem

14

to confirm a suspicion in the reader's mind that this book has concerned itself too much with what he might call 'craftsmen' whereas it should be concerning itself with 'Artists'. It must therefore be made clear that it is virtually impossible to draw this distinction in the Middle Ages, at least in occupational terms. The most eminent painters are found executing commissions which, by present-day standards, might well seem to belong to the 'craft' side of the trade, rather than the 'art'. Melchior Broederlam of Ypres, the skilled and reputable painter of the Duke of Burgundy, was expected to paint standards and decorations as well as altarpieces. In 1386–87 he painted the Duchess's hearse and also the drapery and pavilions on the Duke's boat.

19, 20

In 1390–91 Broederlam did in fact decorate two sets of jousting harness for Philip the Bold of Burgundy and throughout the Middle Ages the painter's calling was associated intimately with tasks which would today be judged menial. The painters' guild in London was for a long time considered an offshoot of the saddler's guild and the early crises about which anything is known all centred on the production of saddles. In Paris in the thirteenth century the guild regulations divided the painters into two groups: those whose primary task was painting saddles, and presumably horse-trappings generally; and those whose primary task was painting images. It is true that the distinction is not clear in the taxation lists already mentioned, although two painters lived actually in the *Selerie* and the second wealthiest painter in Paris lived just off the *Selerie* in the Rue Saint-Jacques. But this confounding of what would now be called 'Art' and 'applied art' is a feature of the Middle Ages.

4

Many regulations survive of which the purpose was specifically to prevent the painter from applying his art with intent to defraud. This has already been mentioned in connection with the London ordinances of 1283. A Florentine provision of 1335 sought to protect the quality of horse-armour. The fifteenth-century Painters' Statutes of Padua made similar reference to painted shields. The Venetian statutes of 1271 contained the general regulation that any vendor had to declare, on sale, whether his objects were new or old – that is, brand-new or refurbished; and the statutes were concerned much more with shields, helmets, chests and (perhaps surprisingly in Venice) saddles than with altar-

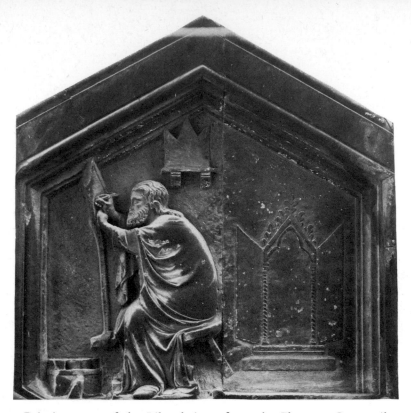

5 Painting, one of the Liberal Arts, from the Florence Campanile, second quarter of the fourteenth century. The artist works at one altarpiece while another stands beside him

pieces. However, the trade in altarpieces did receive attention. Here the danger was not that the article would collapse, perhaps in the middle of a battle, but that the patron would be delivered something, the intrinsic value of which was less than had been paid for. The artist might have employed gold-leaf of unusual thinness, carelessly applied, or an inferior blue in the place of lapis lazuli. In fact, patrons themselves sometimes tried to guard their own interests by specifying in the course of a written contract the materials which were to be used. Thus, in a contract for an altarpiece of 1320, the Bishop of Arezzo ordered specifically that the best gold-leaf of the quality of 100 leaves to the florin and genuine azure ultramarine (lapis lazuli) should be employed.

7

16

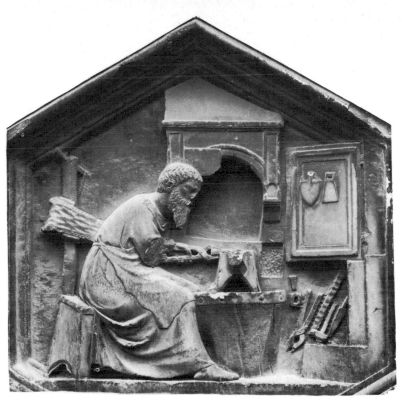

6 Metalworking, from the same series at Florence. The tools of the craftsman's trade are portrayed in some detail: bellows, furnace, anvil, and pliers

An 'image-maker' might be a painter; he was more commonly a specialized kind of mason. A mason was basically someone who worked in stone. But the term covered a wide range of pursuits and an even wider range of skill; and already by 1300 separate trades were included within the wider term. In 1292, there were 104 declared masons in Paris; but clearly there was a wide discrepancy between the King's Mason, who lived in the Cité and paid 6*l* tax, and the majority who paid 5*s* or less. Some of these would have been little more than stone-cutters. They were in any case distinguished in the taxation lists from the quarriers and also from the *imagiers,* and the majority of them must have belonged to the building trade. The *imagiers* were the nearest approach to sculptors

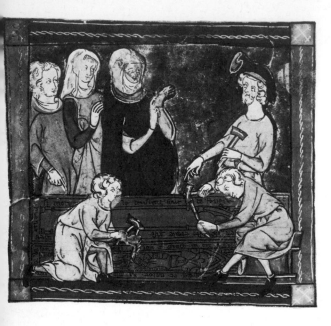

7 *Left:* the tomb-maker, with his assistants, receives instructions from a noble patroness. From a French manuscript of the early fourteenth century

8 The famous artists of legend were generally famous for reasons other than mere excellence in their art. Pygmalion (*below right*, a manuscript of 1470) made a statue so beautiful that he prayed for it to be brought to life

74

7

in the modern sense, producing individual works of greater or lesser quality. Claus Sluter, the famous sculptor of the Duke of Burgundy, was generally referred to as *imagier*. These image-makers were often further distinguished as *marbriers* (marble-workers) and *tombiers* (tomb-makers).

Understandably, less is heard of image-makers as an independent group, probably because of the constant tendency to be absorbed into the general mason's craft. It is true that the Parisian Statutes of 1391 for the image-carvers, sculptors, painters and illuminators are, in fact, very much concerned with carved images; but once again, it seems that it was the power of the painter to conceal basic faults in workmanship which was particularly feared. The pre-amble, in fact, opens by reciting how several poor churches in Paris had been deceived because those concerned with them, such as the churchwardens and others in charge, priests and many other good and devout people, who from devotion had ordered orna-ments of paintings and images, knew nothing about these things. The general tenor of the regulations suggests that a number of images had been marketed which had later fallen to pieces, perhaps while being carried in procession.

18

All this serves to give some idea of the urban setting of the medieval artist; and it is essential to try to grasp its nature because practically every artist of any distinction served an apprenticeship in a setting of this kind. It may well be asked what goals were open to an ambitious artist anxious to establish a reputation in his town. The first point to make is that in repute the arts were not equal. There is no doubt that the positions which carried the greatest prestige were those of senior masons in charge of building works. The whole career of a senior master mason – the results (perhaps a royal chapel), the enormous financial and material responsibility and his engineering expertise – automatically placed him on a different plane from the other artists. The painter or sculptor might indeed become famous but one gets the impression that it was fame on a different scale and of a different kind. In a sense, therefore, the position of the master mason throughout the whole period covered by this book is straightforward. This did not, however, prevent the profession from evolving in a peculiarly interesting way. The results almost certainly affected the status of the architects and the phenomenon is discussed below, separately.

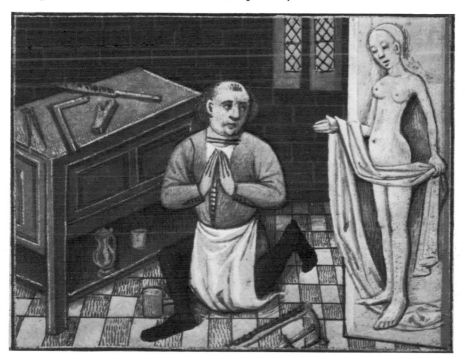

The ladder of success for a mason was reasonably clear since there were a large number of permanent salaried positions as 'surveyors to the fabric' of particular cathedrals or public buildings. But public recognition of this kind for a painter or image-maker was limited or non-existent. To begin with, no town council ever appears to have appointed an official image-maker or sculptor. This is reasonable on account of the architectural context of much medieval sculpture, which would automatically have brought it within the province of the surveyor, himself almost certainly a mason. The post at issue here is really that of 'official painter to the town' – a post which did exist and which, it might be expected, would have complemented that of Surveyor or Master of the Works. The fact that this did not happen deserves explanation since it throws further light on the position, status and prospects of a painter in the city.

Official posts were, in origin at least, intended to satisfy practical needs. Thus buildings needed constant inspection and surveillance; and they received indeed practical attention which was seldom lavished on paintings. Picture conservation was virtually non-existent. The Parisian painters' ordinances of 1391 contain the provision that wall-painters should erase well and truly the old

10

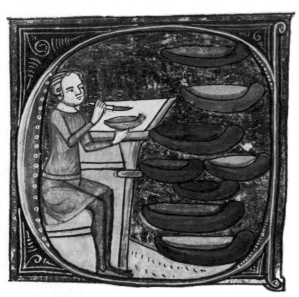

9 *Left:* an artist preparing his colours, from an English fourteenth-century manuscript. The text discusses the etymology of *color* and the picture is in fact the initial C of that word

10 *Above right:* painting murals to decorate the walls of a church, an illustration from a *Bible historiale* of the fifteenth century showing 'the building of Solomon's house'

20

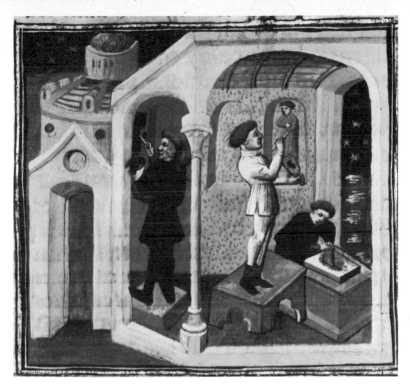

colours of any previous scheme of decoration that they were over-
painting – an observation that throws some light on the attitude
to earlier work. It seldom seems to have been considered necessary
that one man should be singled out and given a regular salary to
execute new civic paintings, much less to look after old ones. Very
occasionally it did happen, but even then in conditions of which
nothing is known. In 1271, for instance, the town council of San
Gimignano voted that the commune should seek out a painter
who was willing to remain permanently in the town, and provide
him with a house and workshop 'in order that he may exercise his
art'. Although this may seem, on the surface, a reasonable practical
proposition, in fact the experience of other towns suggests that, in
normal circumstances, such a step was completely unnecessary. It
has already been shown that in 1292 Paris possessed a 'pool' of
thirty-three painters of varying skill. Other towns must have been
in comparable positions. As long as the level of the 'pool' was
maintained, there was no need to single out one man as Town
Painter. The artists were there, in residence, and municipal work

was assigned to them as and when required. We know when any particular man gave extra satisfaction, simply because his name appears in the municipal accounts year after year. This happened 14 in the case of Simone Martini at Siena (*c.* 1320–33) and equally in the case of an otherwise obscure painter at Ypres, Henri Mannin (*c.* 1311–30). The additional measures found necessary by the town council of San Gimignano in order to attract one permanent resident artist are thus very hard to explain and certainly do not represent common practice. There was no practical necessity to 15 change this state of affairs. Neither of the Lorenzetti brothers nor Simone Martini nor Henri Mannin were appointed to any official position. Yet this had important results. Almost without exception, honorific positions developed originally out of positions of responsibility instituted for practical reasons. The concept of an official painter to the town might have developed if the painter could first have joined the ranks of the town officials as a practical necessity. But until this step was taken (and there was no reason why it ever should have been taken) it was unlikely that the painters would ever 16, 17, 18 secure an honorific position of their own. The case of Giotto illustrates the position in the 1330s. In 1334 he received from the city of Florence a final act of recognition in a successful attempt to get him to stay in the city. As the most eminent Florentine painter, he was made City Architect.

This gives a most illuminating insight into the status of painters. It may well seem surprising that Giotto, today regarded as a founding-father of Italian painting, should not have received honour *as a painter*. But painting was regarded as one craft among many. Something has already been seen of the people and work with which the craft was associated. In modern terms, one might perhaps try to imagine a city council paying homage to a successful local shoe manufacturer. Few city councils nowadays would do this simply by emphasizing his craft unless the position of boot-maker to the mayor and aldermen already existed as an honourable one (which is unlikely). The important point is that some position or title has (and had) to be found which will associate the prospective holder with some form of eminence already existing. This seems to be what happened to Giotto. No position of City Painter existed in Florence; and even had it occurred to the Florentine authorities to make Giotto City Painter, this would merely have

22

associated him more closely with the type of appointment already noted at San Gimignano, which seems to have been one of desperation rather than honour. To make him City Architect, however, was a very different proposition. Although, as far as we know, completely untrained as a mason, he was given as it were a commission into the ranks of the senior master masons; for they were the only medieval artist-craftsmen to achieve an international standing and eminence which Giotto had himself achieved *in spite of* the fact that he was only a painter.

The position of Painter to the Town does, however, make a sporadic appearance towards the end of the Middle Ages — so sporadic, indeed, that generalizations are almost impossible. In 1400, at Ypres, a painter named Jacques Cavael, who had worked on civic commissions satisfactorily for some years, petitioned that, in return for painting a current order of banners, banderoles and costume designs free, he might receive the title of Town Painter. His wish was granted and he was given permission to wear the robes of a town official. It is not clear whether a regular salary was attached to this position. Cavael had a successor in 1406 when a France van der Wichterne petitioned for and obtained the same office. From published records, the office seems then to have lapsed. The famous painter Roger van der Weyden held a similar post at Brussels in 1436. To him too was granted the right to wear the cloak of a town official. In his case, some sort of payment was received since the abolition of the post was discussed in connection with a series of economy measures. Roger also had a successor in the worthy but totally undistinguished Vrancke van der Stockte. Finally, one may instance the official painters of the Venetian State towards the end of the fifteenth century, paid out of State funds and holding as a sinecure the official position of a broker at the *fondaco* of the German merchants. *13*

One can do little more than conjecture about the motives behind the institution of these posts. It is striking that at Brussels, the post was considered at one stage a luxury which the town could hardly afford; and this idea of a luxury commodity may hold the key to the situation. For it seems likely that the positions originated not as practical necessities, nor yet with the idea of honouring particular artists, but with the idea of honouring the town itself by giving it an additional status symbol. The *peintre de la ville* was perhaps

appointed in imitation of the *peintres du roi* or *peintres de monseigneur le duc* who appear more and more frequently during the course of the fourteenth century. Unfortunately, if this was so, the course of this particular development is still extremely obscure. But it does not seem that, as a general rule, a medieval painter (or figure-sculptor) would have expected formal recognition of his skill in his craft from his home-town; nor would he normally have looked for any official position in his home-town which he could ultimately hope to hold. As far as can be judged, the rewards that he sought for his skill were more direct ones; and his success would have been judged not by titles but by the standing of his patrons. In his immediate vicinity, this patronage would certainly have included civic commissions. In addition, however, there would have been commissions of corporations and religious confraternities. Finally, there would be commissions of private individuals. At the top of the scale of private patronage stood the court; and at this point the court becomes an immediate focus of attention. For the general status of painters – and other artists – as a class in society will certainly be illumined by the way in which those at this level were treated. The following section, therefore, will begin by examining the way in which artists were associated with a medieval court and the ways in which they were absorbed into its structure.

11 Another miniature by Master Honoré, from *La Somme le Roy*, *c.* 1290. The figures are Humility (a crowned female figure standing on a unicorn), Pride (Ahaziah) having a fall, the repentant sinner, and Hypocrisy (pointing derisively at the sinner)

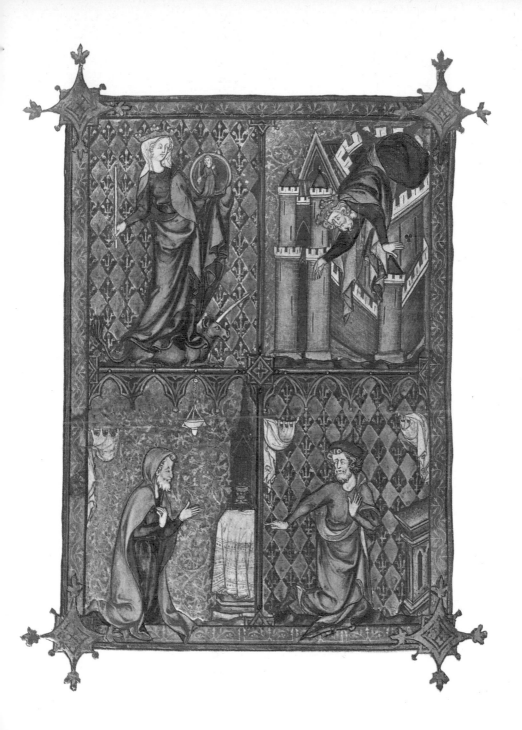

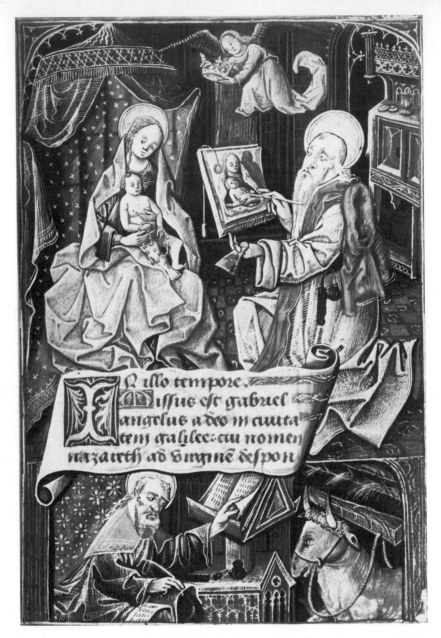

In the scroll: I n illo tempore. Missus est gabriel angelus a deo m cuuta tem galilee: cu nomen nazareth ad virginem despon

12, 13 St Luke was traditionally believed to have been a painter, and the legend that the Virgin sat to him for her portrait goes back to the sixth century. These two examples belong to the fifteenth. *Above:* miniature from a French Book of Hours. *Right:* detail of a painting by Roger van der Weyden

14, 15 A city such as Siena could draw on the services of many gifted painters and therefore found no need to appoint a Town Painter. In the early decades of the fourteenth century Simone Martini's name occurs repeatedly in the records (*left:* a detail from his *Maestà* in the Palazzo Pubblico), as later do those of the Lorenzetti brothers (*right:* part of *Good Government*, in the same building). None of them, however, held any official position

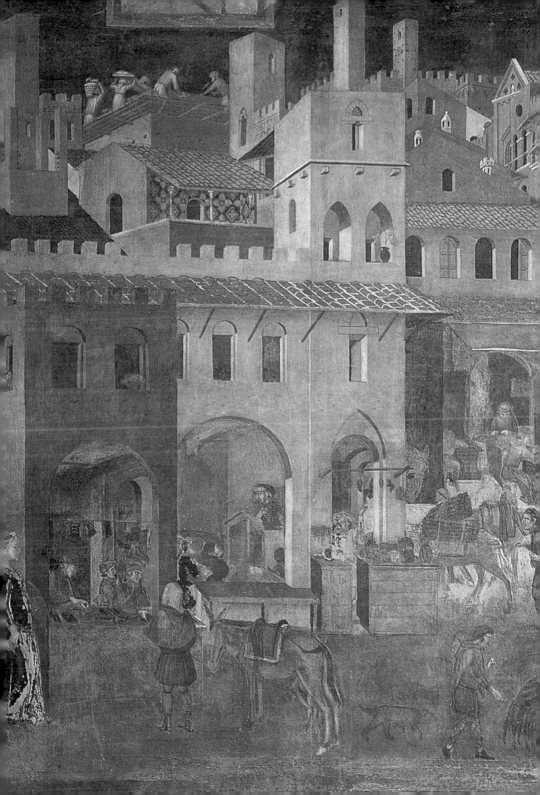

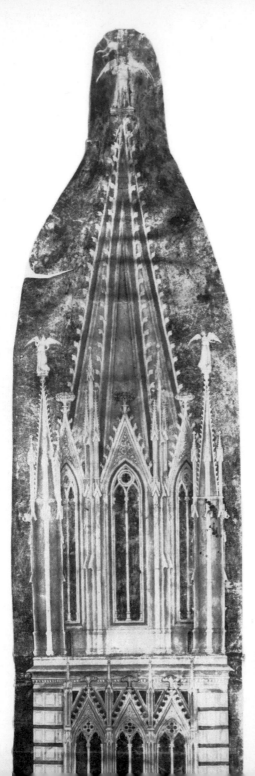

16, 17, 18 A master mason had social standing, a master painter not. Giotto was one of the first artists to win fame and recognition as a painter, but it is symptomatic of the painter's status that in order to honour him the Florentine authorities should have given him the title of City *Architect*. The *Ognissanti Madonna* (right) is one of the masterpieces of the early Trecento. By contrast, Giotto's architecture is less important. When designed, his Campanile was apparently intended (*left*) to have a polygonal spire and lantern – a typical *rayonnant* feature. As finished by Francesco Talenti later in the century (*below*) it still relied strongly on coloured patterns for its effect

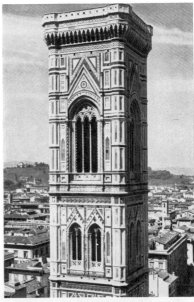

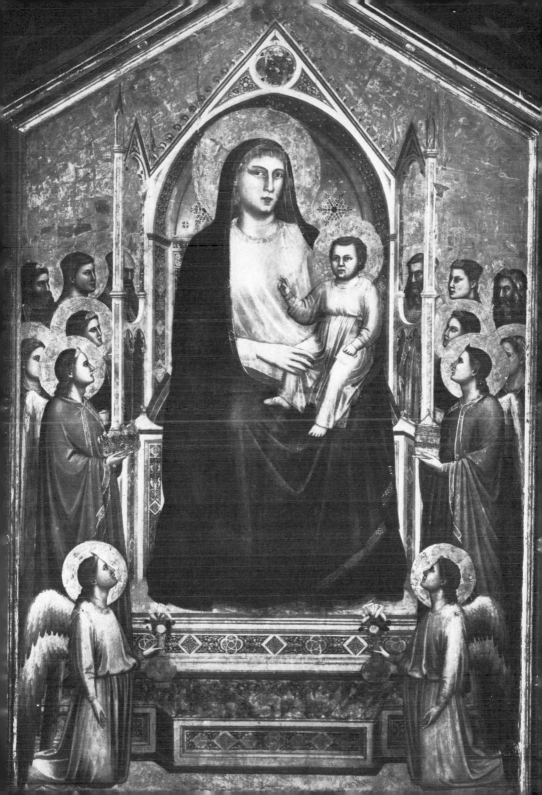

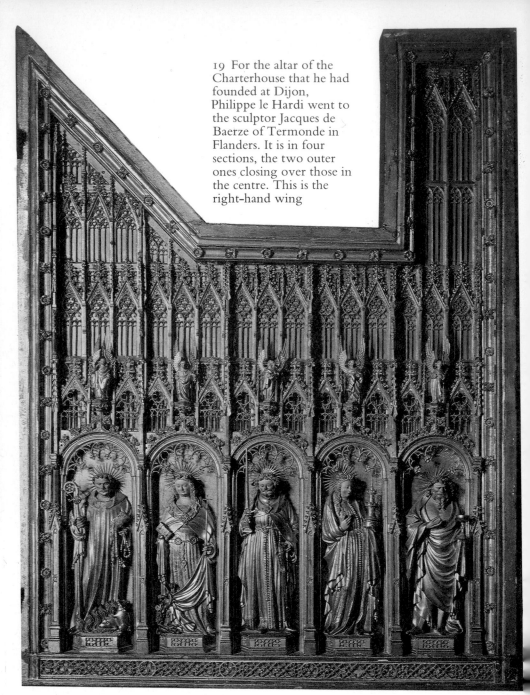

19 For the altar of the Charterhouse that he had founded at Dijon, Philippe le Hardi went to the sculptor Jacques de Baerze of Termonde in Flanders. It is in four sections, the two outer ones closing over those in the centre. This is the right-hand wing

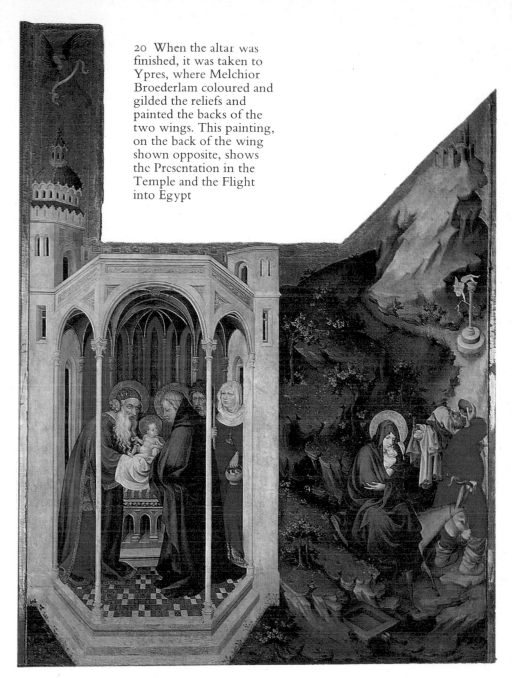

20 When the altar was finished, it was taken to Ypres, where Melchior Broederlam coloured and gilded the reliefs and painted the backs of the two wings. This painting, on the back of the wing shown opposite, shows the Presentation in the Temple and the Flight into Egypt

The Artist at Court

To be more precise, we should examine the relationship of artists to the royal household. Not every medieval monarch felt it necessary to keep artists in his immediate *entourage*, that is, his household. The kings of England are an example. Neither Henry III nor Richard 31 II, two of the most cultured medieval kings, appears to have kept a painter or illuminator there. For instance, of the various painters who worked for Henry III the most eminent was probably Walter of Durham; but he was called 'King's Serjeant and Painter' — not an office attached to the household. His salary by 1271 was derived from three separate sources, suggesting in itself an *ad hoc* arrangement to pay an office for which no regular Exchequer provision existed. Under Richard II, two painters called Prince acted successively as King's Painter but it was not found necessary to give them any more specific appointment. They did not even receive a regular salary but were paid for piecework through the office of the Great Wardrobe.

A similar state of affairs seems to be found in France about 1300. Nothing definite is known about the artists employed by the thirteenth-century kings of France, and there is at least no sign of any special relationship to the royal court. Master Honoré, who 3, 11 has already been mentioned, may have produced books for the royal chapel but he does not appear to have had any official standing. In the first two decades of the next century, three *émigré* Roman painters (including the reputable Filippo Rusuti) received pensions from the French Treasury. They are styled variously *pictores regis* and *peintres nostre sire*, but, as with Walter of Durham in England, no closer association with the Crown is suggested. Another *émigré* Roman painter, Pietro Cavallini, was invited to the Angevin court 39 at Naples in 1308. Again, although he was granted an annual salary 38 and a house, no court status appears to have been assigned to him.

Perhaps, before proceeding further, something may be said

35

21 Queen's Painter: Jean Pucelle's frontispiece for the Book of Hours painted for Queen Jeanne d'Evreux, about 1325. In the initial D Queen Jeanne kneels at prayer. The original page is only 3½ inches high

22, 23 One of the court painters at the imperial court in Prague, about 1360, was Master Theodoric. *Left* and *above*: two of his works, his patron Charles IV (detail), and St Jerome

about a medieval royal household – the organization to which, so far, artists have not apparently belonged. On inquiry, this will perhaps not appear particularly surprising. The royal household was primarily an administrative service which kept the king fed, clothed, mobile (when necessary) and (if one adds the normal establishment of fools and minstrels) amused. It was large and complicated and organized on typical civil service lines in departments. The duties and allowances of each member of each department were defined by household ordinances which were drawn from time to time as occasion demanded; and, scanning the personnel of these departments from the bedchamber to the stables, it is admittedly very difficult to imagine both the practical circumstances in which an artist could be brought on to the strength of the court and the department to which he would be attached, should this occur. For whatever section one chooses – bedchamber, butlery, hall or whatever – none seems quite fitted to take, as it might be, a working manuscript-illuminator.

However, between 1300 and 1315 this development did take place in the circle of the French royal family. In Naples at the

Angevin court in 1310, a painter called Montano of Arezzo was received into the royal household (*inter familiares*), and in Paris in 1313 in the household of Philip the Fair there was an illuminator called Maciot. Maciot was included in a court roll under the general category of *valeti et alii hospitii* or *valeti et familia hospitii*; they were as a general rule the members of the royal household who were neither noble, clerical, knightly nor legal. It was a category that included the members of the chief household departments such as the kitchen and the stables already mentioned, and was the obvious grading for a supernumerary craftsman. In view of what has just been said, however, it is interesting that his position in the household was not further defined. We shall return to this point.

Membership of the *familia hospitii* is also implied by the other expression already mentioned – *familiaris*. It was in this classification that the celebrated Florentine artist Giotto was eventually placed *38* when he visited Naples. The text of the royal order of 1330 confirming the appointment still exists and runs as follows:

> Freely do we associate in the community of our *familia* those approved by the uprightness of their ways and commended by their distinctive excellence. Sensible therefore that Master Giotto of Florence, painter, *familiaris* and our faithful servant, is sustained by prudent deeds and exercised in fruitful services, we willingly receive him as our *familiaris* and retain him in our household, that he may possess and enjoy those honours and privileges which other *familiares* possess, after taking the accustomed oath.

This development was apparently not followed in England but echoes of it occur elsewhere in Europe. In 1367, at the imperial court of Prague, the painter Theodoric was styled in the course of *22, 23* an imperial grant 'beloved master . . . our painter and *familiaris*'.

As a part of the history of the rise of the artist, this development should have great importance; yet in many ways it raises nothing but questions. In the case of Maciot, for instance, he came in 1302 from the counts of Artois to serve the French King. He was, however, given a house of his own in Paris; and although this was on the Cité, he had moved to the north bank by the time of the taxation roll of 1313 and had a house in the parish of Saint-Merri. This was the year of the court list in which he is mentioned.

At this point, an obvious problem emerges. Why could not Maciot, from his workshop in the parish of Saint-Merri on the north bank, supply the royal family with works as Honoré had done from the parish of Saint-Séverin on the south bank? Why was it necessary to place him on the establishment of the court among the *valeti et alii hospitii*? The same problem occurs in the case of Giotto. What different circumstances operated which made it necessary to *38, 39* make Giotto of Florence a *familiaris* when Cavallini of Rome had merely been given an annual salary and a house?

In view of Giotto's subsequent eminence, his appointment has generally received considerable notice. It is, therefore, necessary to disembarrass it of some of its reputed grandeur. In the first place, the language of his appointment, imposing in itself, seems nevertheless to have followed a civil service formula, since an almost identical form of words was used for the similar appointment of an otherwise unknown clerk in 1316. It is frequently pointed out that Petrarch was accorded the same distinction in 1341. At the other end of the scale, however, one has to remember the royal Neapolitan barber called Simonetto who in 1297–98 is also called *familiaris noster*. This single example makes it likely that Giotto at Naples was being granted an appointment similar to that of Maciot at Paris among the *valeti et familia hospitii*.

It is, incidentally, necessary to emphasize the distinction between general service to the king and service at court. Montano had already been working for the Angevin royal family; Giotto was first retained on a monthly salary without the title of *familiaris*. Moreover, Giotto's salary was increased in 1332, independently of his allowances as a court servant. Unfortunately nothing is known of the circumstances of the appointment of Maciot, although he was positively removed from the royal household in the Ordinance of 1319. The main point here is that, from the start, membership of the royal *familia* seems to have been something extra enjoyed at the top of a professional career.

It has already been suggested that there is no apparent obvious professional reason for drafting an illuminator or painter on to the strength of the court. The artists must have arrived at court because the king wanted them there. There is, indeed, only one solid reason for placing them on the strength of court personnel – namely, that they would have right of access to the court and it would

38

consequently have been easier for a king to get at them, should they be required. Now, why *should* the king require them? Not surely to satisfy unpredictable peripatetic urges for art. High-quality manuscripts or panel-painting are not produced in the makeshift surroundings of a royal progress from palace to palace. The only compelling reasons must have been found in personal links between artist and king which are now lost – links that need not necessarily have had anything to do with art at all.

The fact is, of course, that we are still in the prehistory of artistic personalities. We have to wait until the sixteenth century to have it recorded that Raphael or Leonardo had demeanours which were acceptable at court. However, there is one instance in the first half of the fourteenth century of a painter entertaining a king in a non-professional capacity. This happened in 1326, not in France but in England. In the Wardrobe accounts for this year the Treasurer accounted for a gift of money paid to 'Jack of St Albans, painter

24 The artist-craftsman, his patrons and social equals. This French manuscript from the mid fourteenth century shows in the foreground a goldsmith making a pyxis, with the king's falconer and other retainers

of the King, who danced before the King on a table'. Jack of St Albans was not, apparently, a regular member of the household establishment. But it is sufficient to illustrate that kings could call upon unexpected resources for their entertainment. There is, however, no need for us to imagine Giotto in the undignified posture of dancing upon a table. In this connection, it is sufficient to remember Vasari's stories about Giotto's career at Naples. Vasari wrote in the mid-sixteenth century. There are no grounds for supposing that this account is anything but apocryphal and it is usually dismissed out of hand. The social order had not, however, radically changed between 1330 and 1550 and, whoever invented these stories, they must represent, however faintly, something of the personal qualities which helped to transform the ordinary *pictor regis* into *familiaris*.

> [Giotto's works] much pleased that king, by whom he was so greatly beloved that many times, while working, Giotto found himself entertained by the King in person, who took pleasure in seeing him at work and in hearing his discourse. And Giotto, who had ever some jest on his tongue and some witty repartee in readiness, would entertain him with his hand, in painting, and with pleasant discourse in his jesting. Wherefore, the King saying to him one day that he wished to make him the first man in Naples, Giotto answered, 'And for that end am I lodged at the Porta Reale in order to be the first in Naples.' Another time, the King saying to him, 'Giotto, if I were you, now that it is hot, I should give over painting for a little', he answered, 'And I, i'faith, if I were you'. . . . Now the King having one day out of caprice besought him to paint his realm for him, Giotto, so it is said, painted for him an ass saddled, that had at its feet a new pack-saddle, and was sniffing at it and making semblance of desiring it; and on both the old pack-saddle and the new one were the royal crown and the sceptre of sovereignty; wherefore Giotto, being asked by the King what such a picture signified, answered that such were his subjects and such a kingdom, wherein every day a new lord was desired.

It seems to be the case that artists were only admitted to the household after serving the king for some period of time, which suggests, again, that the king's desire was for closer association as

the result of previous experience. One cannot, therefore, help suspecting, as a result of all this, that Maciot may have been a brilliant personable young man, that Montano of Arezzo perhaps had an inexhaustible fund of wit and that Giotto really was a fascinating character. In fact, like Master Honoré and Pietro *3, 11, 29*
Cavallini, all these men were in the first instance brought to the royal notice as a result of success in their craft. Their presence in the household, however, seems unlikely to have had much to do with their talents as artists and may be taken to demonstrate that, unlike Master Honoré and Pietro Cavallini, they had personalities which were congenial to the princes whom they served. In these circumstances, the three Limbourg brothers who were taken into *27*
the household of the duc de Berry may be seen not only as superb manuscript-illuminators but also as a sort of Netherlandish Bushy, Bagot and Green.

Such people have always been subject to a variety of pressures. It is not merely that they get called the 'caterpillars of the common-wealth'. Social considerations apart, painters were not easily assignable to any known administrative category – this problem has already been noted. Maciot, in fact, appears in a preliminary list of names, many of which have no occupation added to indicate attachment to any particular household department, and there would normally be a tendency on the part of the king to collect extra people on top of the given establishment. It is, how-ever, equally to be expected that there would be a strong admini-strative tendency to tidy these people away, either by expelling them from the court (not always possible) or by lodging them in an existing administrative 'pigeon-hole'. The artists appear to have got both types of treatment. A laconic note in the French household ordinance of 1319 says 'That, Guy and Maciot the illuminator shall be removed', the full significance of which is now lost.

The second course was adopted later in the century. There was one Royal Painter called Girart d'Orléans who was employed by *25*
the King's works on and off from 1328 until 1350. Then suddenly, with the accession of John the Good, he was described as 'our beloved *familiaris* . . . painter and usher of our hall'. This is hardly an expected appointment. The 1318 Ordinance of Edward II of England makes it clear that the duties of these *ushers* were to keep order in the hall, to make sure that the place was decently appointed

and to exclude gate-crashers. In terms of allowances, this position was not especially exalted and indeed it seems to have undergone a decline at the fourteenth-century French court. Girart in any case had a salary as a Royal Painter of 6s a day – far in excess of the cash allowances ever given to working ushers (2s per day in 1285; 1s 7 deniers in 1317; 9d in 1386); he was, therefore, being paid for a completely different job. He also had a house in Paris on the north bank by 1356. And, in all, it seems likely that the appointment must have been a purely nominal one.

To make a painter Usher of the Hall may be unexpected. There was another position, however, which seems even stranger. This was the appointment of Sergeant-at-Arms. These men were the personal bodyguard of the king and were supposed to mount guard while he was at table or at Mass. They also rode as escort while he was travelling. Two men received this title. The painter, Jean Coste, having served the Crown at least since 1349 (with the title of peintre du roy since 1351), was suddenly referred to as peintre et sergent d'armes du roy in 1367. (This is the last surviving reference to him.) One other fourteenth-century master to receive this title was the Master of the King's Works at the Louvre, Raymond du Temple, according to a document of 1395. In the case of Jean Coste, at least, it is hard to take this appointment seriously – to imagine, in fact, a painter after over ten years' faithful service suddenly being chosen as a bodyguard. A more likely explanation is available, however. The sergeants-at-arms numbered thirty (at least in the Ordinance of 1317), and it is likely that there would frequently have been vacancies in their numbers. When Charles V desired to have Jean Coste at court, it may only have been possible, administratively, to accommodate him as a sergeant. Everyday experience suggests that, whereas Charles would not have minded what his painter was called so long as he was at hand when required, the Master of the Household or the Master of the Chamber of Accounts would not have been happy until he could be labelled with some existing tag. There are no grounds for supposing that administrative 'regularization' is an invention of the twentieth century.

There was a third household position which eventually became far more commonly occupied by painters and other craftsmen. It is interesting that, here at least, some sort of rational development

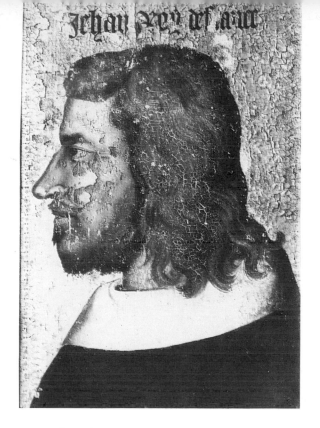

25 John the Good, King of France (1319–64). The portrait was probably painted by Girart d'Orléans, 'our beloved *familiaris*', who held the official position of 'usher of the hall' and went with the King into captivity in London in 1356 as his *valet de chambre*

can be demonstrated. It is connected with Girart d'Orléans, the painter whom we have already met nominally as an Usher of the King's Hall. 25

He was mentioned as Usher once more in a document of 1355. In 1356 the French were defeated by the English at the Battle of Poitiers and King John was taken prisoner to London. Girart d'Orléans went with him and during the course of the three years' captivity executed various small works. In these circumstances, his position as Usher of the King's Hall would have been meaningless, since the King's Hall as an institution virtually ceased to exist in John's London quarters at the Savoy. In 1356, therefore, Girart is found as 'Servant of the Chamber' and in 1359 as a 'Valet of the Chamber' – or, to use the normal French expression, *valet de chambre*.

Girart had, therefore, moved from the Hall to the Chamber. In the hierarchy of the household, the *valets de chambre* received

43

allowances similar to the cooks or the furriers. They were almost certainly superior in prestige, however, since they were the personal attendants on the king. Their normal establishment included the king's tailor, his pharmacist and his barber. To illustrate the nature of this move in modern terms, one might therefore suggest that Girart d'Orléans was being promoted from titular 'N.C.O. in charge of the Men's Mess' to 'Commanding Officer's Batman'.

Moreover, in this particular case of Girart d'Orléans, it is possible to feel that he was, in some sense, a personal companion to the King. When King John of France was taken prisoner his court was necessarily reduced in number and the main departments were held in common with his son Philip, later Duke of Burgundy, who shared his father's captivity. All this can be deduced from such accounts as survive, and those accounts also reveal who was in permanent attendance on the King. During the six months from December 1358 to June 1359, John had his previous freedom considerably restricted and he came under a surveillance closer than at any previous time, largely as the result of the contemporary political and military situation. Moreover, he was moved in April to Hertford Castle, and thence to Somerton Castle (Lincolnshire) in July and finally brought back to London (March 1360) where he was lodged in the Tower. Throughout this period he held together round him a court of sorts. During the six-month accounting period already mentioned, certain permanent office-holders appear, such as the *maistre de l'ostel*, the King's Secretary, the royal chaplains (one of them the King's Physician) and the clerks to the chapel. King John also had in attendance the Royal Fool and the King of the Minstrels. Five *valets de chambre* are mentioned. None was a barber since John borrowed a barber from the retinue of his son. One was a tailor who was not in London in December but came over from France in March. Two further *valets de chambre* are mentioned who were *espiciers* (apothecaries). One came over from France in March and returned in May, the other was only appointed to the position in May. A further *valet de chambre*, whose occupation is not specified, left France in April. The only *valet de chambre* permanently in attendance on the King during this period was the painter Girart d'Orléans who apparently never left the court. During this period he executed a number of paintings for John and also constructed a *jeu d'échecs*, and these tasks may well

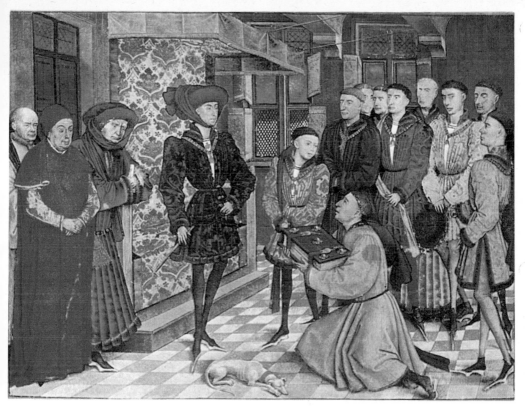

26 Philip, also called 'the Good', great-grandson of John and Duke of Burgundy, inherited his love of the arts. Here he receives Jacques de Guise's *Chroniques de Hainault* from Simon Nockart. Behind him stands another outstanding patron, Chancellor Nicolas Rolin (see pl. 40)

be taken as symbols of his dual capacity. Not only was he a good painter; he was also personally companionable and (like the Fool) had some sort of entertainment value.

The step of admitting a favourite craftsman to the royal chamber was in some ways expected, and it is admittedly obscure why Girart d'Orléans was made Usher. It can only be suggested that the chamber establishment (which was small and fluctuated between about six and a dozen in numbers) was full at that point. But precedents were already to be found at the court of Edward II, who had a carpenter as a *valet de chambre*; and however much

conservative opinion might grumble about the presence of these menials round the king, the establishment of the chamber was an obvious niche in which to lodge them.

Once the step had been taken of admitting an artist to the royal chamber, the precedent was set and the appointment became a frequent one. Girart d'Orléans was followed in 1364 by a painter Jehan d'Orléans, *valet de chambre*, who is likely to have been a relation. Jehan was followed by a François who was certainly his son and who succeeded in 1404 during the lifetime of his father.

34, 35 Jean Bandol, King's Painter since 1368, was probably admitted to the household in 1378 or 1379. The royal dukes admitted to their 74 chambers as valets numerous gifted artists, including Claus Sluter, 19, 20, 27 Melchior Broederlam and the Limbourg brothers. In fact, by the close of the fourteenth century, the position of *valet de chambre* at a French court appears to have been a common appointment for any sort of craftsman or artist who might have taken a patron's fancy; for instance, goldsmiths, *tapissiers*, illuminators, embroiderers or musicians are all found in this post.

One cannot, I think, ignore at any time the personal aspect of 40, 41 the appointment. It is not merely that Jan van Eyck, *valet de chambre*, was sent on confidential missions by his master, the Duke of Burgundy, although this illustrates the point. But quite famous fourteenth-century artists are not recorded in any household 75, 76 position – for instance, André Beauneveu and Jacquemart de Hesdin. 32, 33 What is, however, completely obscure is the obligations incurred by accepting one of these posts. One cannot perhaps take the ushers and sergeants seriously; but were companionable artists ever required to do regular service in the chamber? The answer is not at the moment clear.

The obligations of a King's Painter (as opposed to a *valet de* 34, 35 *chambre*) are more easily found. In 1374 Jean Bandol, already *pictor regis*, was granted an annual salary of 200 *livres* 'on this condition, that he shall be held to serve in all works of painting that the King shall command without other wages, either for himself or his servant'. The conditions of payment naturally varied between 25 Bandol who was paid about 13s a day 'all in' and Girart d'Orléans who was granted a salary of 6s a day in 1350 but was paid in addition for whatever work he executed. On top of this, patrons might often add presents of money, by way of encouragement.

46

27 Jean, duc de Berry, was among the most lavish patrons of his time. From the Limbourg brothers he commissioned perhaps the best known of all medieval illuminated manuscripts, the *Très Riches Heures*. This picture, showing the Duke setting off on a journey, was added by the same artists to the earlier *Petites Heures du duc de Berry*

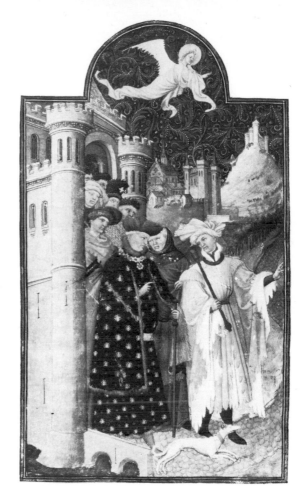

The main purpose of the patron was to retain a good craftsman for use at any required time. The same position presumably held good for Walter of Durham. Occasionally the restrictions were severe. A document of 1365 records how the painter Jean de Hasselt had been retained by Louis de Mâle, Count of Flanders, to work 'in our chapel at Ghent and elsewhere where it shall please us, without attending to any other work other than ours without our consent and permission'. Jan van Eyck's appointment of 1426 *40, 41* used a far less stringent formula; the Duke merely made the appointment 'in order that he [Jan] shall be obliged to work at

painting for him [the Duke] as often as it shall please the Duke'. No explicit restraint was placed on outside commissions.

Houses were sometimes provided by patrons. François d'Orléans and his father were living in lodgings in the royal palace at Paris

28 ln 1404. Henri Bellechose, *valet de chambre* and painter of the Duke of Burgundy, rented a house from the Sainte-Chapelle at Dijon –

27 probably obtained, therefore, at the instance of the Duke. Pol de Limbourg was presented with a house in Bourges by the duc de Berry. There does not seem to have been any definite rule. The prospects of these men also varied. The Limbourg brothers seem to have prospered financially since Pol was able in 1415 to lend the duc de Berry 1,000 *écus* – a very large sum of money for a craftsman. Very occasionally attempts appear to have been made to better their families as in the case of Drouet de Dammartin. He was a master mason of the duc de Berry and in 1413 had sent his second

37 son to study in Paris. His first son, however, followed the family craft and became a mason, but he in turn sent a second son to study law. An unusual if obscure distinction was conferred on another

36 mason, Jean de Cambrai. In 1375 he was merely a 'hewer of free stone' at Cambrai. In 1397 he was a *valet de chambre* of the duc de Berry, living at Bourges. Finally, in 1403, he was formally called *esquire* in an order from Charles VI authorizing him to wear the collar of the *Geneste*.

The most obvious disadvantages of serving a prince were financial, for payment or repayment might be erratic. The largest single item in the 1413 will of Drouet de Dammartin was a debt from the duc de Berry of 2,000*l.* This was an extraordinarily large sum, equivalent to about ten to fourteen years' pay for a competent mason. Nothing, however, is known about the circumstances of the debt. The Limbourg brothers, in the loan already mentioned, had extracted a security from the Duke in the form of a ruby which covered the value of their loan three times over. But no mention of a security was made by Drouet. Lack of wages apparently

26 reduced one illuminator of the Duke of Burgundy to poverty. A grant of 1459 by Philip the Good of Burgundy recites how Jehan de Pestimen had served the ducal family since his youth and had been a *valet de chambre* since 1418, serving the ducal court as long as he was able. Nevertheless, he had not been able to have the wages belonging to his office and now, at the age of about sixty-

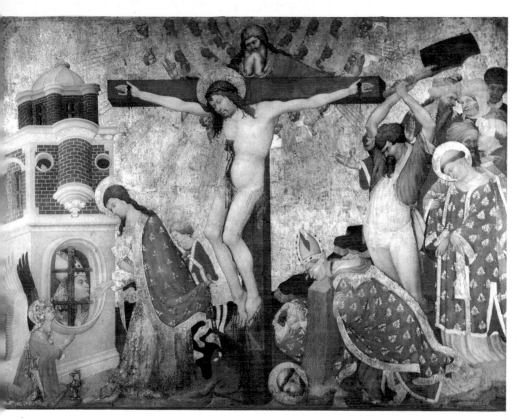

28 A painter's position in a noble household was still vague and undefined. Henri Bellechose, who painted the *Martyrdom of St Denis* for the Duke of Burgundy in 1416, was entered as *valet de chambre* on the pay-roll

eight, he was reduced to begging. The Duke, therefore, granted him a pension of 30*l* a year. Pestimen had lived at Dijon since about 1432 and this probably explains his poverty. The Burgundian Duke seldom came to Dijon after about 1425 and the permanent establishment at Dijon suffered as a result, particularly where art was concerned. Supervision of the construction of the tombs in the ducal mausoleum at Champmol varied in character from laxity to mismanagement; and, apart from Pestimen, one other artist is known to have suffered from absence of wages. This was Henri *28* Bellechose, a painter who had received his official appointment at

Dijon in 1415 but appears to have gone without pay from 1429 till his death sometime after 1440. There was no question of Duke Philip being merely uninterested in art because in the Netherlands he had during this period three other painters and *valets de chambre* including Jan van Eyck. The artists at Dijon, nominally attached to a court which was never there, were simply thrown on their own resources. According to Bellechose himself, he had been reduced by poverty to letting his wife run a market-stall.

It is always assumed, of course, that artists, thrown on their own resources, can manage. But painting is partly a luxury and, reflecting on the fantastic expenditure on luxuries by a court of the early fifteenth century, it is easy to see the extreme consequences of the removal of any court for those supplying the luxuries. One can only imagine that the mercers and furriers of Dijon were as sharply affected as the painters.

The work expected from court artists may well have been monotonous. Palace decoration often consisted in the repetition of formal patterns although full-scale history-painting is sometimes mentioned. The demands of the age of chivalry on painters may well have seemed excessive. Hugh of Boulogne, painter, *valet de chambre*, colleague and contemporary of Jan van Eyck in the service of the Duke of Burgundy, seems constantly to have been involved in situations in which he and a band of subordinates had to work night and day to complete on time monstrous orders involving thousands of pennants and a great many escutcheons and banners. To end this survey of the position of the artist at court, therefore, something should be said about one of the more bizarre appointments about which anything is known. It was at the castle of Hesdin, which belonged in the fourteenth century to the counts of Artois and passed at the end of the century to the dukes of Burgundy; and the appointment was that of 'Master of the Amusement Machines and of the Painters'. The counts of Artois had constructed in their castle at Hesdin a gallery of machines for the diversion of their guests and the amusement of the household. Something existed already in 1299 but, unfortunately, there is no full description until 1432. The machines, however, were constantly in need of repair and refurbishing throughout the fourteenth century and it seems likely that additions were made from time to time. As a gallery of diversions, they illustrate the somewhat Edwardian sense

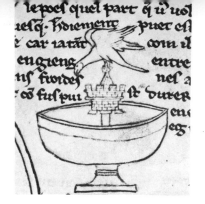

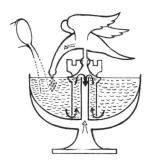

29, 30 It was not considered unbecoming for a serious artist to apply himself to jokes, *jeux d'esprit* and mere toys, as one learns from Villard de Honnecourt's notebook of the mid thirteenth century. *Above left:* 'This is a contrivance that may be made in a drinking cup.' It consists of a bird which sits on top of a tower in the middle of a wine-cup, and when wine is poured in seems to drink it up. The mechanism is explained in the accompanying (modern) drawing. The cup is hollow at the base, and has a tube rising inside the tower to a point just below the rim of the cup. The bottom of the tower is perforated to allow wine to flow into it. When the level of the liquid rises in the cup it overflows inside the tower (unseen) into the hollow base. Air is forced up into the bird and out through its beak, producing a bubbling sound as if it were drinking. Villard's drawing is misleading since it shows the bird's beak considerably higher than the rim of the cup.

of humour of a medieval court. Most of the machines caused various forms of discomfort to anyone who had the misfortune to be invited to inspect them; most of the ensuing 'fun' depended on two classic standbys of slapstick humour, the jet of water and the bag of flour (or soot). Here are some of the devices which the painter at Hesdin was required to look after; the list represents the accumulated ingenuity of about 130 years; the result was an achievement reminiscent of Leonardo da Vinci and certainly worthy of him.

There was a general provision of machines for projecting water for the whole length of the gallery so that if it was required nobody in the gallery should escape being soaked. At one point there was a separate room painted with figures and histories, the ceiling decorated with gilded stars and other devices and having a large pendant keystone adorned with figures dressed in imitation cloth of gold. This room must have been arresting to look at. Moreover, those entering were spoken to by a wooden figure of a hermit by

the entrance. Above the ceiling was a machine for producing water like rain from the sky, and thunder, snow and lightning 'such as is seen in the sky'; and in the floor at one point was a trap down which those escaping from the 'rain' fell into a large sack where they were smothered in feathers. Various carved figures throughout the gallery projected water without warning at on-lookers. Three jets near the entrance covered people who stopped in front of them with flour. There was an imitation window which, on being opened, revealed a figure who soaked the onlookers with water and closed the window again. On a table was an imitation book of ballads which smothered those who opened it with black (soot?) and also sprayed them with water when required. Along-side was a mirror where victims of the book were sent to look at themselves, only to be covered in flour again. Perhaps the master-piece was a carved figure in the middle of the gallery which could be made to command in the voice of the Duke that all those in the gallery should leave immediately. Those taken in by this voice would rush towards an exit where they were assaulted, by large figures, on the head and shoulders and finally propelled across a bridge which precipitated them into water beneath. Those who were not taken in and stayed put were nevertheless drenched with water.

All this may seem to belong more properly to the by-ways of social history until one suddenly finds no less a person than Mel-chior Broederlam ordered to conduct a general overhaul of the machines in 1386. One would dearly like to have seen some of the devices after Broederlam had finished with them.

One might pass directly from this point to the question of the way in which medieval artists were treated by the society in which they lived and the general problem of the status attached to their craft. Before doing this, however, there are two totally different groups of artists to be considered. The architects will be discussed last of all. The second group consists of those men living in religious houses and under religious vows. Set apart from the strains of commercial and social competition, they too demand for these very reasons to be considered apart from the others. At this point, too, it will be necessary to step back in time, since the greatest achievements of monastic artists belong to a period before the fourteenth century.

52 31 Richard II was one of the most cultured English kings, com-missioning works from both English artists and visitors from abroad. The *Wilton Diptych* (detail, *right*, showing the King), perhaps *c.* 1395, may stem from England or France

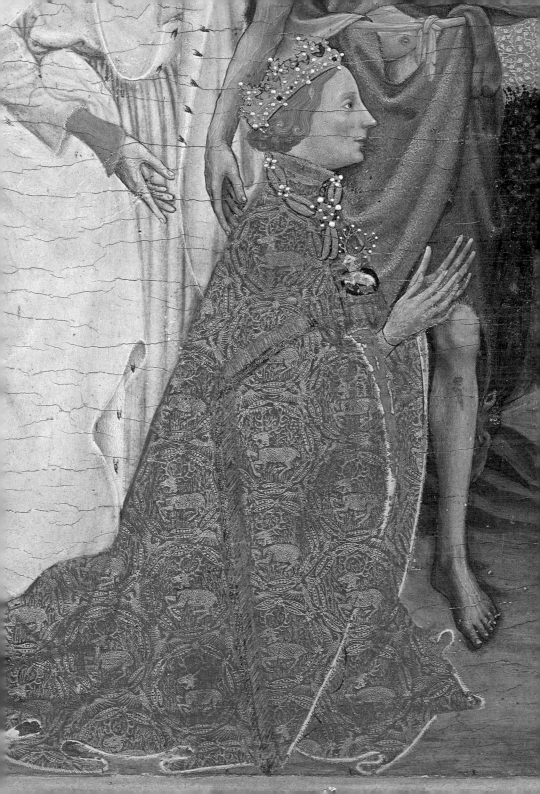

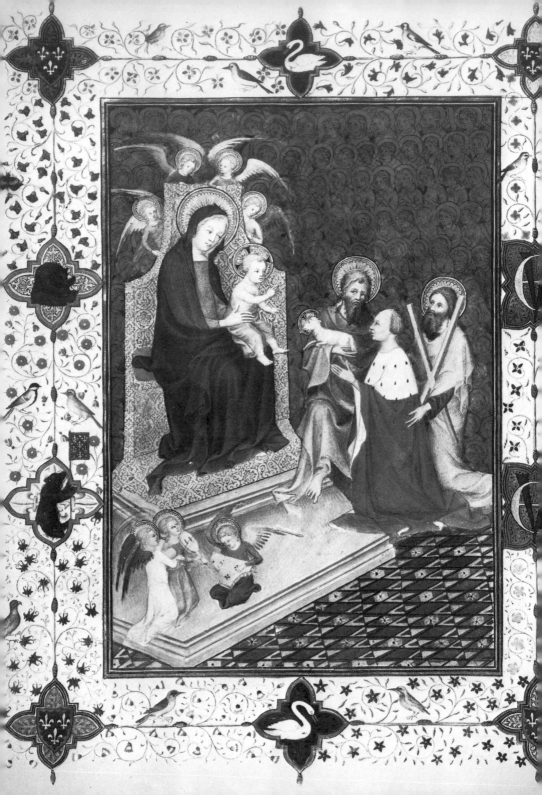

32, 33 Jacquemart de Hesdin worked for the duc de Berry as a manuscript illuminator and as a decorator of his palace at Poitiers. These two illustrations are probably, but not certainly, from his hand. *Left:* the duc de Berry being presented to the Virgin by Saints Andrew and John the Baptist, from the Brussels Hours, *c.* 1400–11. *Right:* drawing of the Madonna and Child from a sketchbook

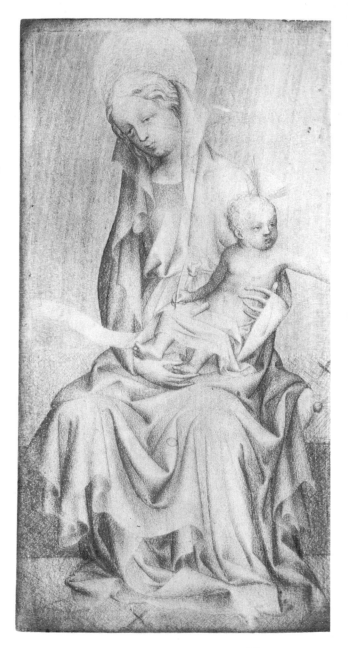

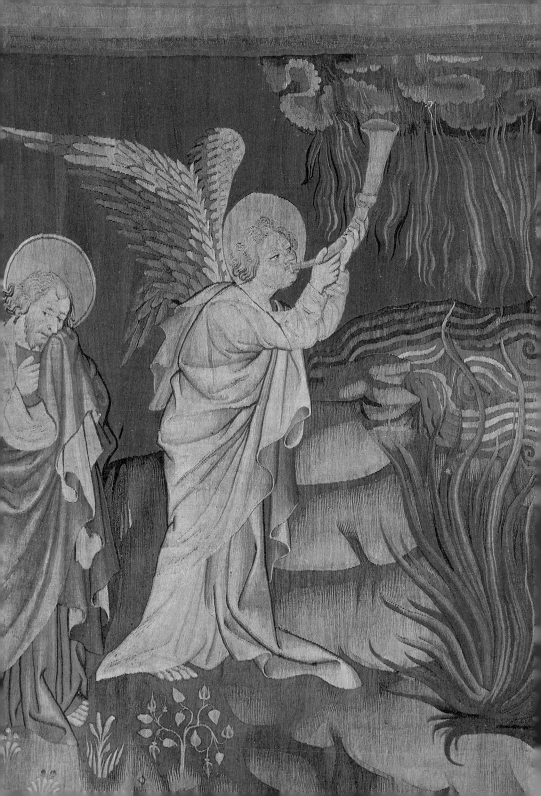

34, 35 Jean Bandol, *pictor regis* to King Charles V of France, helped design the series of Apocalypse tapestries, *c.* 1379, now in the castle of Angers. This detail (*left*) shows the Angel sounding the Second Trumpet. He also painted the frontispiece to King Charles's Bible (*below*), in which Jean de Vaudetar, one of his courtiers, presents the book to his sovereign. Charles wears the cap and gown of a Master of Arts of Paris

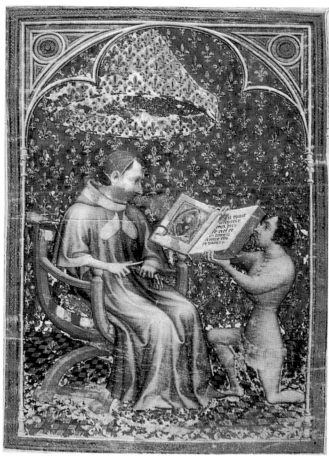

36, 37 Sculptors at the court of the duc de Berry. *Right:* Duchess Jeanne, by Guy de Dammartin. The statue stands at one end of the great hall of the palace of Poitiers, rebuilt by the Duke after it had been burnt down by the English. *Below:* the Duke's tomb in Bourges Cathedral, by Jean de Cambrai, recorded in 1375 as a 'hewer of free stone' and in 1397 as the Duke's *valet de chambre*

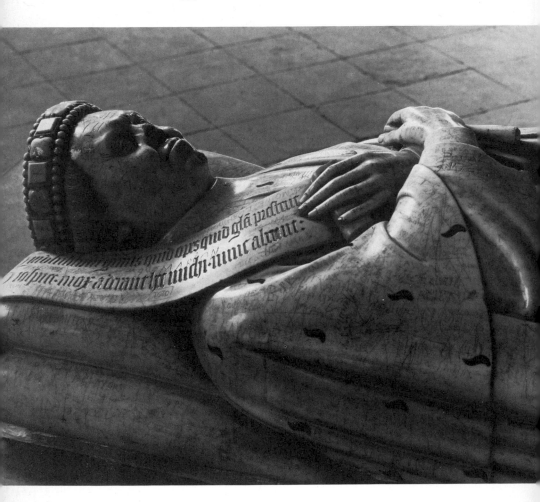

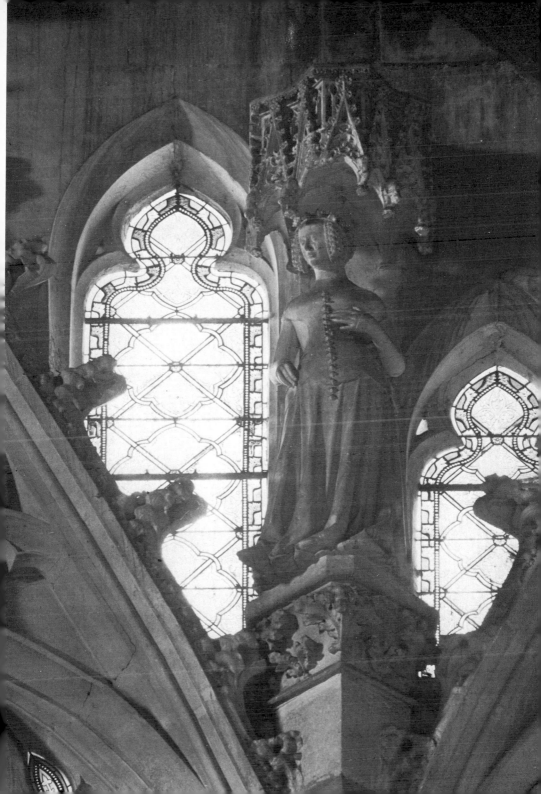

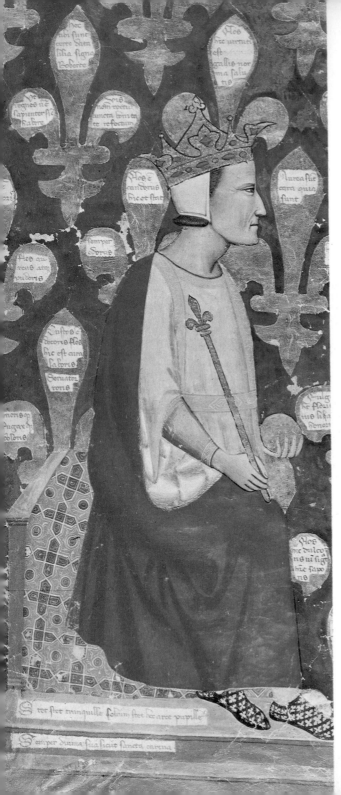

38, 39 *Left:* Robert of Anjou, King of Naples for thirty-four years (1309–43), and patron of both Cavallini and Giotto. Vasari tells several stories of the familiar relationship between the King and Giotto which, though apocryphal in detail, probably represent the situation fairly enough. *Right:* detail from Cavallini's fresco of the Last Judgment in Sta Cecilia, Rome, *c.* 1290. Little of his work at Naples survives

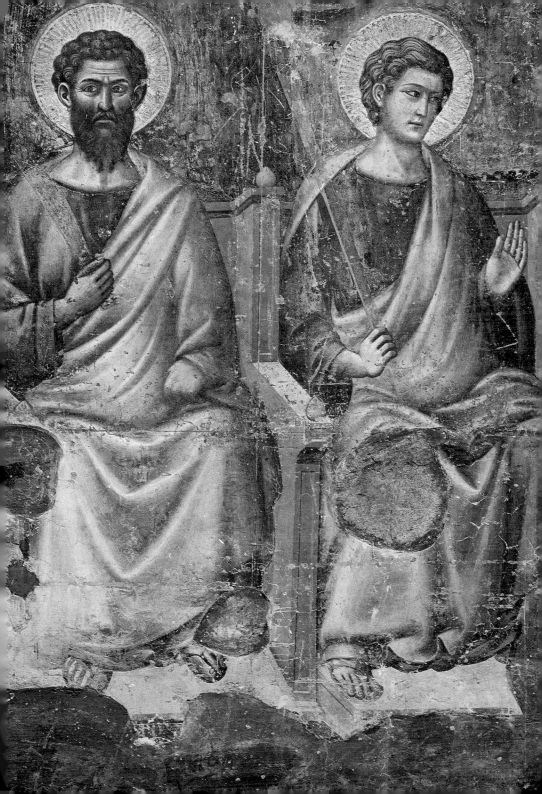

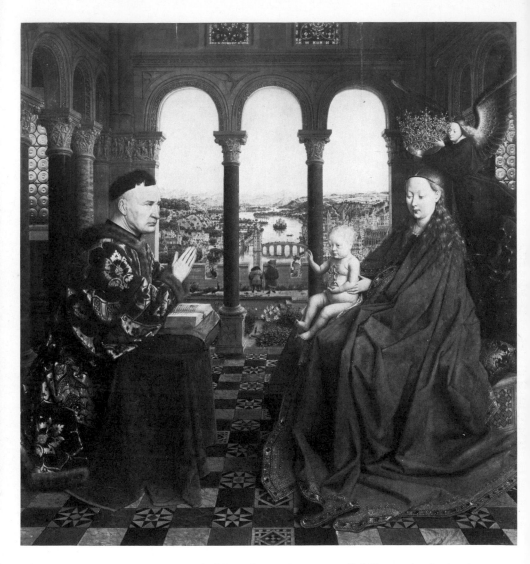

40, 41 Jan van Eyck, like other artists, was officially a *valet de chambre* to the Duke of Burgundy. Although, unlike the rest, he is known to have been sent on official missions, his main employment can only have been as a painter. *Above:* the Madonna with Chancellor Rolin. *Right: Leal Souvenir,* or *Timotheos,* believed to be a portrait of Giles Binchois, a musician at the court of Philip the Good

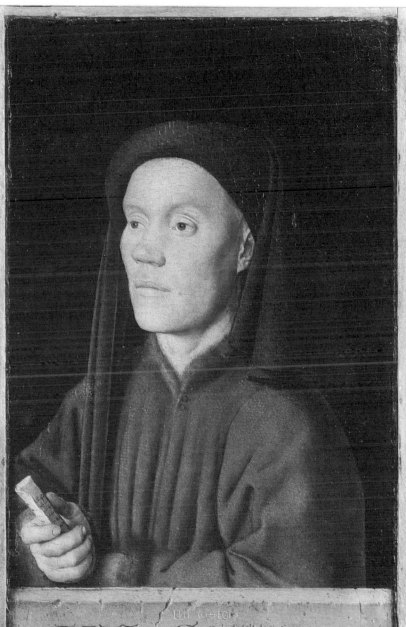

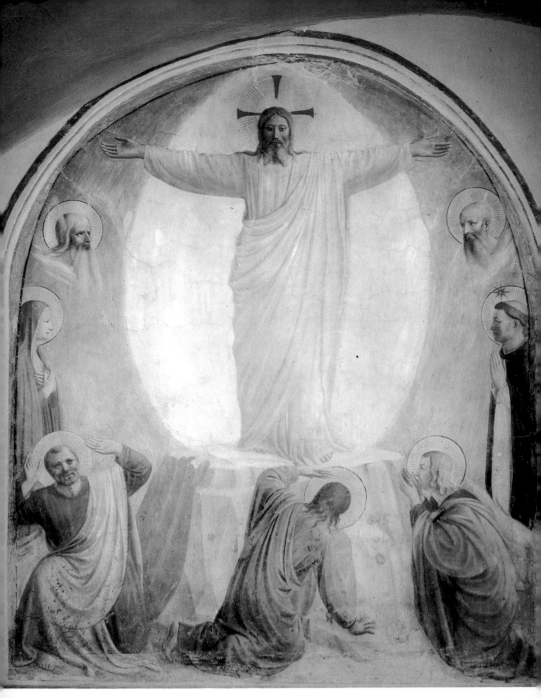

42 The Transfiguration, one of the frescoes painted by the Dominican Fra Angelico in the cells of brother friars at San Marco, Florence

The Artist in the Cloister

The intention of this section is to deal generally with artists who belonged to some form of religious community and were bound by vows to some form of religious observance. While many of the artists were monks, it will be remembered that some, like Fra Angelico, belonged to a Mendicant Order. They have, however, this in common: in theory at least, their art was a part of their existence subordinate to the religious purpose to which their lives were dedicated.

Religious observance and art have never necessarily been incompatible. St Benedict, in the monastic Rule which ultimately became the basis of Western monasticism, foresaw the situation in which a monastery might admit craftsmen. Certain hours of the day were set aside for manual labour; and in Chapter 57 of the Rule, he wrote that craftsmen should be allowed, with the permission of the abbot, to practise their crafts. They should, however, not allow their skill to be a source of temptation to pride and anyone boasting was to be removed from his work until he had humbled himself. If their work was to be sold outside the monastery, those who sold it had to be scrupulous in the valuation and then to sell it slightly below its market price. Craftsmen or artificers were admittedly envisaged in general here. St Benedict probably had in mind carpenters or cobblers as much as people who would now be called artists. Nevertheless, his terms applied equally to the goldsmith or the illuminator.

These terms of admission for the artist may seem harsh or unrealistic, but, considering St Benedict's main purpose, rather the reverse is true. He was trying to set out the general conditions in which a community of men might serve God and seek out its own salvation. 'We must establish', he said, 'a school of the Lord's service; in founding which we hope to ordain nothing that is harsh or burdensome. But if, for good reason, for the amendment

42

65

43 Medieval artists often signed their work, sometimes in amusing ways. Here William de Brailes put his name to the small figure of a monk being saved by St Michael on the Day of Judgment – 'W. DE BRALE ME FECIT'

of evil habit and the preservation of charity, there be some strictness of discipline, do not be at once dismayed and run away from the way of salvation, of which the entrance must needs be narrow.' To find this way of salvation was the only purpose of a monk's life. However, St Benedict was humane enough to know the benefits of creative activity. Above all, it was a weapon against the 'enemy of the soul', idleness; it might also provide material necessities for the monastery. St Benedict's only concern was that at no point should the activity, whatever it was, become a source of sin, either to the creator or to those through whose hands the created products might later pass.

At this point the writings may be cited of a practising monastic artist who called himself Theophilus. He lived probably in the earlier part of the twelfth century in north-west Germany; and he produced a treatise *Concerning the various arts* which recounted his entire experience as a craftsman. In the present context, it is interesting that three prefaces were written in the course of the treatise, all of which suggest at the very least that Theophilus was trying to put into practice the intentions behind St Benedict's words. Individual genius was not admitted by Theophilus. The artist was not seen as someone struggling to develop a personal gift but to

66

rediscover an inheritance which was there for anyone to take. 'Whoever will contribute both care and concern is able to attain a capacity for all arts and skills as if by hereditary right. . . . What God has given man as an inheritance, let man strive and work with all eagerness to attain. When this has been attained, let no one glorify himself as if it were received of himself and not Another but let him humbly render thanks to God. . . . Nor let him conceal what has been given in the cloak of envy or hide it in the closet of a grasping heart. But, repelling all vainglory, let him with a joyful heart and with simplicity dispense to all who seek. . . . I, an unworthy and frail mortal of little consequence, freely offer to all, who wish to learn with humility, what has freely been given me by the Divine condescension, which gives to all in abundance and holds it against no man'. Theophilus also urged his readers to study the useful arts particularly, because of the 'honour and advantage there is in eschewing idleness and in spurning laziness and sloth'. His work, in fact, reads at times almost like a gloss on the words of St Benedict.

One has little means of telling how widespread this attitude was among monastic artists. Numerous inscriptions survive in *43* manuscripts in which the scribe says a few words about himself. Sometimes these are merely a pious self-recommendation:

> *Hunc librum solus monachus descripsit Amandus*
> *Pro quo perpetuae comprendat munera vitae.*
> (The monk Amandus alone wrote this book,
> for whom may it obtain the rewards of perpetual life.)
> (early twelfth century)

Sometimes the writer, in a manner similar to Theophilus in his first preface, asks for the prayers of the reader.

> *Huius scriptori Willelmo sedulus oret*
> *Lector, opem reddat gaudia tuta Deus.*
> (May the zealous reader pray for the writer of this, William;
> May God grant [him] secure joys [and] help.)
> (early thirteenth century)

Against this type of sentiment, however, has to be set the occasional self-laudatory one. The most famous example is probably that of Eadwine who was a monk of Christchurch, Canterbury, *44*

about 1140. He left the following inscription round a picture of himself:

> I am the prince of writers; neither my fame nor my praise will die quickly; demand of my letters who I am.
> The Letters: Fame proclaims you in your writing for ever, Eadwine, you who are to be seen here in the painting. The worthiness of this book demonstrates your excellence. O God, this book is given to you by him. Receive this acceptable gift.

Only rarely is one given any detailed information about craftsmen in a religious community. The comparatively small amount of information does not, however, represent the tip of an artistic iceberg. There are no grounds for supposing that every monastery was a forcing-house of artistic activity. This appears perhaps more clearly when one examines the types of art most commonly associated with religious houses in general and monasteries in particular. The service of monks who were craftsmen was devoted in the first place to the supply of necessities. Since part of the monk's day was given over to reading, there was a permanent need for texts in the library. Thus, it was convenient that every monastery should have a *scriptorium* of its own. The church services required a certain amount of plate and utensils, and these too were sometimes made in the monastery. The church was often decorated with paintings
48 and painted images which might be done by a monastic painter. At no time, however, was it essential that these activities should be carried out by the monks themselves. Everything depended upon circumstances, in particular on the most easily available sources of supply. Any monastery could and would buy from the secular world, should this be convenient, and from the twelfth century
46 onwards there is increasing evidence for the existence of secular craftsmen working in towns on a commercial basis.

On the whole, stone sculpture was beyond the scope of monastic craftsmen, being too closely attached to the masons' craft which already in the twelfth century was usually in the hands of profes-
49 sionals from the outside world. But book-illumination, painting and metal sculpture were certainly practised by monks. Theophilus makes this explicit. His first part is devoted to painting. The third part is devoted to metalwork and includes bell-founding. The second part, which deals with glass-painting and staining, adds a

68

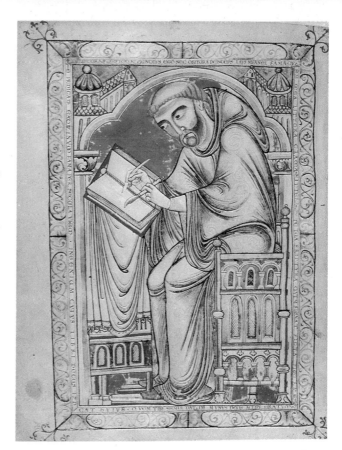

44 Eadwine, monk of Canterbury, had no false modesty about the excellence of the manuscript which he finished about 1149. The inscription round his portrait is translated opposite

further category of art to the list. Furthermore, scattered references bear out the fact that professed monks could and did practise all these crafts.

The process by which art in any particular religious house developed, flourished and declined is for the most part still a matter of conjecture. Life in a wealthy house was in general congenial to the practice of art but it would certainly be wrong to see a 'monastic school' as an impersonal movement. So soon as evidence becomes available, any such 'school' appears to revolve round particular individuals, as in the case of Fra Angelico at the convent of San Marco in Florence. Throughout the Middle Ages, the sources provide only a sprinkling of names of such individuals, and frequently in the course of time their works have been destroyed so that their

42

names alone remain. One may cite in the twelfth century Master
50 Hugo of Bury St Edmunds, praised by the Bury chronicler as a
metal-smith and a manuscript-illuminator. He may have executed
the so-called Bury Bible but any sculpture has vanished. Matthew
Paris recounted the names of a group of four painters working at
St Albans in the first half of the thirteenth century but no work can
47 now definitely be assigned to them individually. Matthew Paris
himself was said to be competent as a sculptor and goldsmith
besides being a scribe and illuminator, but, once again, any sculpture
has been lost.

It is unlikely that monasteries generated their own schools of
art. Indeed, it can occasionally be shown that artists were imported
from outside, ready-trained. This might happen simply by trans-
ferring a trained artist from one monastery or convent to another;
but equally, a convent sometimes recruited a fully-trained secular
craftsman into its ranks. It is possible that Theophilus, already
mentioned, had such a background since what he wrote is not in
some places entirely what one might expect of a monk writing for
other monks. Matthew Paris tells of the painter, Walter of Col-
chester, who was attracted into the monastery of St Albans by a
monk already there called Ralph Gubiun; and, although he is not

45 Brother William, of
St Albans, one of a family
of artists in the mid
thirteenth century, two of
whom became monks.
This sketch is by Matthew
Paris

70

46 Peter Vischer, with his sons, made the shrine of St Sebaldus for the church dedicated to him at Nuremberg and left this self-portrait as a signature

explicit, the inference is that Walter was a practising painter before becoming a monk. Paris also tells of a family of painters of whom the senior member William became a monk at St Albans. William had a brother Simon who was also his pupil; but since Simon never became a monk, William must have been proficient enough to train him before he himself entered the monastery. Finally, Simon had a son Richard, also a painter who, following in the steps of his uncle William, also became a monk. This particular group of three painters is interesting because, during the first part of the thirteenth century, they painted, according to Matthew Paris, altarpieces for all the altars in the abbey church. Had these altarpieces survived, one would have a 'school' of monastic painting which consisted, in fact, precisely of three men (one a layman); and although the position of Richard may be open to question, it is nevertheless likely that none of these three men was actually trained in the monastery.

45, 51

It seems likely, on reflection, that in order to start a monastic 'school of art' some contact with the outside world was necessary, either with another monastery or with a secular workshop. Moreover, any abbot or sacrist interested in the production of church fittings and ornaments within his monastery, or in the continuation of such a tradition, would have faced a constant problem of recruitment. Theophilus's humble dictum, that anyone was 'able to attain a capacity for all arts and skills as if by hereditary right' provided that they devoted to them enough care and concern, may have had a limited validity; but the great manuscripts of the twelfth and thirteenth centuries are clearly not the work of painstaking amateurs. It must always have been a problem to find prospective monks who were either promising artists or already proficient. It may not be fanciful, therefore, to see Walter of Colchester as something of a *coup* for Ralph Gubiun and the monastery of St Albans.

On the whole, however, it is extremely difficult to get a clear idea of the train of events by which the greater monastic artistic achievements came to be produced. Certainly wealth and importance played a part; but beyond this, the apparent reluctance of monastic chroniclers to interest themselves in art has robbed us of any detailed insight into the 'contingent and the unforeseen' which must certainly have played a large part. Even apart from this, the caprice of fortune has deprived us of large slices of evidence; widespread destruction of plate and glass and the almost total disappearance of certain major monastic libraries, like that of Westminster Abbey, make the broadest generalization fraught with danger.

47 'Frater Mathias Parisiensis', kneeling at the feet of the Virgin, is Matthew Paris, monk, author and artist. The page is from his *Historia Anglorum*, mid thirteenth century

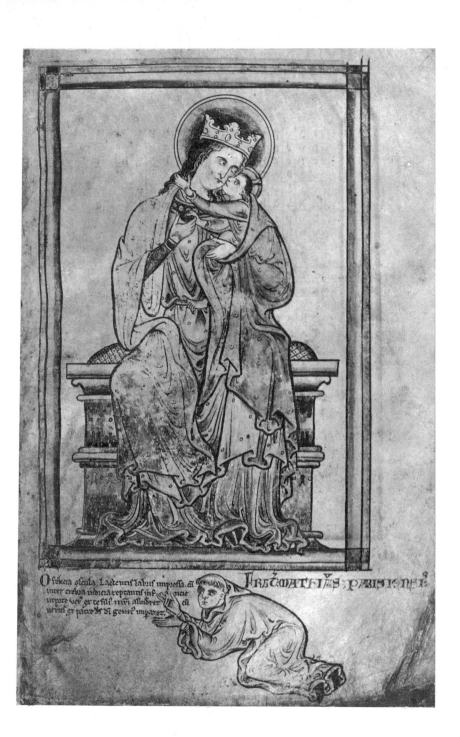

O ferena ofcula Lacteinif labrif impreffa. et
inter crebra iudicia reptannf inf. que me
iuipore uer et te fili inui affudrer eu
uenif et patre et di gente imparer.

FR̄ MATHĪꝰ PARISIĒⳠ

48, 49 Art in the cloister.
Left: a Benedictine monk
painting a statuette of the
Virgin, from an English
manuscript of the
thirteenth century.
Right: frontispiece
from a twelfth-century
manuscript of St Ambrose.
In the centre a monk
paints a shrine. The
roundels show the
production of a book
from the sharpening of
the pen and the
preparation of parchment
to the final binding and
embellishment of the
cover

50, 51 Works by monastic artists. *Above:* Christ in Majesty, with the symbols of the Evangelists, from the *Bury Bible*, perhaps by Master Hugo of Bury St Edmunds. Hugo is known to have been also a metal-worker. *Right: Apocalyptic Christ* by Brother William of St Albans

Alpha z w. viuens
in secula seculoru

Hoc opus fecit fr
Will's de ordine mino
ru socius br prefect
Secund in ordie ipi. co
iisa coe sct na coe angl's

155

he z multe z duces
marcella uccaluit
q oib; relictis sicut
apl's z uera pietatis
uestigia sectatur
iugiter

breus desepera dm

acta seuera locucio seri
Serena serent

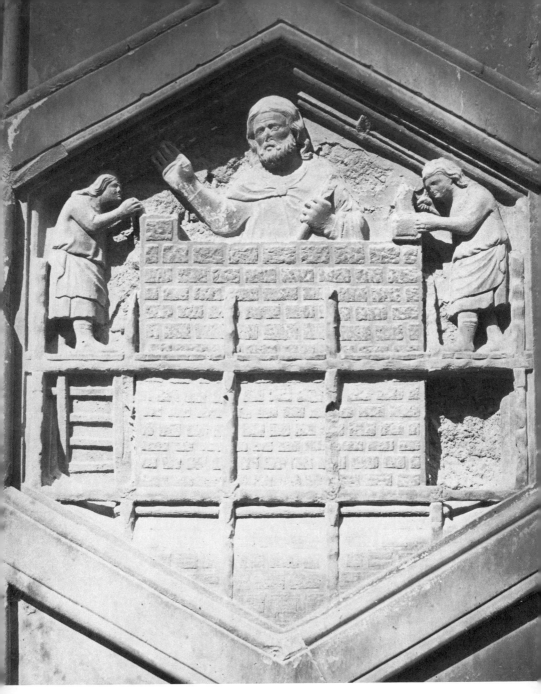

52 The art of building, from the series of reliefs in the Campanile of Florence Cathedral. The master mason directs his workman

The Architect

It is probably anachronistic to write about 'architects', at least in the earlier Middle Ages, since the word itself was very seldom used. The people one is concerned with are those men with a mason's 52 training who reached senior managerial positions. In terms of the period covered by this book, this was probably comparatively early. Certainly by the twelfth century one finds a small corps of top architects in the royal service concerned with activities which were to be the province of architects down to the nineteenth century – palace-building, castle-building, church-building, defence works and miscellaneous military engineering. Throughout this period, architects could become highly paid royal or civic servants. Their special expertise meant that at the very start they fell on their feet. Reliable architects were (as they still are) much in demand.

It is probably possible to document a certain amount of improvement in the position of the architect as far as things like salary, perquisites and pension rights went. But these changes, though interesting, were peripheral. The biggest change in the character of the profession can be deduced from the character of the ecclesiastical buildings that were put up; to anticipate, by the end of this period, it looks as if architects expected to exert a degree of control over the finished architectural effect which would have been unexpected in the early Middle Ages.

Architects have the unenviable reputation for being masterminds. This idea had a limited currency in the Middle Ages to the extent that God creating the universe was sometimes portrayed as an architect with a huge pair of dividers. But in the early Middle Ages, the reality was rather different. Abundant evidence exists to show that Romanesque churches were often heavily painted. The same was and is true of some Gothic churches (for instance the Sainte-Chapelle, Paris). The activities of the painters varied enormously. In some buildings, they limited themselves to touching

79

up the carving and, curiously, to covering over the joints of the masonry with an independent system of painted masonry courses of their own. In other places (for instance Saint-Savin-sur-Gartempe) convenient flat areas were used for history-painting. In other places, especially in Italy, they 'improved' the architecture by painting in columns, pilasters, capitals and even windows that did not exist in the original structure. It would be arguable that all this was done under the eye of the original architect, but for the fact that there are many Italian examples where it is clear that the painting of the building was proceeding long after the original architect had gone or passed away (an important and vivid example is the Upper Church of San Francesco, Assisi). At the very least, there must have been a large contingent in the profession that understood their job to come to an end with the problems of general design and engineering. They were not concerned with the finish of the building down to the last detail and embellishment.

The same sort of considerations apply to stained glass. Few people go to Chartres Cathedral for the architecture, although it is important in its own right. This ignoring of the structure derives partly from the fact that it is rather difficult to see. The stained glass, while undoubtedly producing splendid optical effects, obscures some of the outline and most of the detail. All early stained glass is heavily coloured and tends, where it survives in quantity, to obscure the architecture.

In both painting and stained glass, one gets the impression that the process of finishing a building meant getting hold of the best available artists and allowing them a very remarkable amount of freedom. This is also the impression created by the sculpture. The great transept portals of Chartres Cathedral must have been foreseen by the designer of the building. But the large number of different sculptors involved reinforces the impression of an office of works reaching out to obtain whatever good sculptors were free and then letting them get on with the job.

One obvious change occurs in stained glass. It becomes progressively lighter and one can consequently see the building better. Compare here the sort of thirteenth-century glass in Bourges Cathedral with the thirteenth-century glass in Beauvais Cathedral. Then, in the second half of the century, buildings show an intensified interest in tracery patterns and, ultimately, in vault designs.

80

53 Builders in the early Middle Ages: a twelfth-century fresco in the church of Saint-Savin-sur-Gartempe

These are specifically architect's interests. They have nothing to do with sculpture or painting; they are thought out on a drawing-board in the architect's office. The emphasis on painting and sculpture in practice diminishes. This does not mean that, in general, these arts decline in quality. It means that the best artists are less often required or willing to work on buildings. Many late medieval buildings appear, in their detail, poor and impoverished.

But the total effect is generally more unified – although not, for that reason, more interesting. Subjectively, the fourteenth-century nave of Canterbury Cathedral gives a firmer impression of a master-mind at work than the late twelfth-century choir. Nor is this simply a development of the 'Gothic North'. Brunelleschi's architecture fits surprisingly closely into this general pattern; and his churches are the work of a 'master-mind' in a way that the earlier Florentine

59
58

churches are not. It has often been observed that the greatest achievements of fifteenth-century Florentine painters are almost none of them in fifteenth-century churches. This is largely because Brunelleschi refused to have his carefully judged interiors ruined by indiscriminate fresco-painting.

66

The reasons for this development must now be a matter for speculation. In a sense, it represents a natural progression in the general direction of tidying up the job and setting it on an altogether firmer professional basis. There were, however, two particular factors which may have speeded things up. The first is that, up to about 1220, architecture was as much concerned with engineering as anything else. The tendency the whole time was towards increasing size. Churches became broader or taller; arcades became wider, windows larger. From about 1220 onwards it must have become increasingly obvious that the limits of safety had been reached. Consequently, the engineering aspects of the profession tended to recede and these other interests, all connected with aspects of design, came to the fore. At almost the same date, there appears to have been some sort of undocumented crisis within the profession of mason. Up to the advent of naturalistic sculpture, it would be possible to argue that all sculpture was in some sense an adornment of the building. But as soon as figures began to look like actors on a stage, the whole question of the relationship between sculpture and setting was raised. Was the sculpture an adornment to the architecture? Or was the architecture a stage for the sculpture?

The distinction may seem a small one, but it contains a vital issue of professional principle; and it can be illustrated quite simply. The Port-Royal on the west front of Chartres Cathedral has sculptural decoration which is indubitably an adornment to the architecture in the sense that every part tends to reinforce the lines of the architectural composition. In the central portal of the west front of Rheims (c. 1220–40) this relationship is no longer clear. The figures project from their background and act out little dramas among themselves. The portal has become a stage. The most famous of these 'architectural stages' is certainly the west choir of Naumburg Cathedral (c. 1250). Here the illusion of a building peopled by actors of the sculptor's creation is virtually complete.

64

65

The same issue emerges interestingly in two later Italian buildings. Chronologically, they are reasonably close together. The

82

54 Plans and elevations were certainly used by medieval architects, though few of them have survived. This design for the façade of Orvieto Cathedral, of shortly before 1310, is probably by Lorenzo Maitani

first is the façade of Siena Cathedral, designed for much of its present height by the sculptor-mason Giovanni Pisano about 1285. The second is the west front of Orvieto Cathedral, designed by the architect/engineer-mason Lorenzo Maitani about 1310. They show totally different approaches. Giovanni Pisano's building is heavy 61 and angular; it is also quite obviously a stage for a stupendous array 60 of gesticulating figures. Lorenzo Maitani's façade is smoother and 63 more relief-like. Its major figure-sculpture is in fact relief of 62 extraordinary delicacy and accomplishment which seems in places to melt into its setting. The other major decorative medium is mosaic. Maitani's façade appears quite plausibly to have come 54 straight off a drawing-board.

It is in no sense here argued that either solution is 'right'. The point of interest is that during the thirteenth century the possibility of conflict between sculptor and architect becomes much more

obvious, and this in itself would tend to reinforce the existing tendency on the part of architects to assert that they were designers and engineers rather than manual workers. It is, indeed, arguable that they thought of themselves primarily as designers. This, of course, would be the other side of the coin of Giotto's appointment as City Architect at Florence. It was certainly a post of honour; but by the fourteenth century it was not an incongruous idea that it should be held by a painter who could, presumably, act competently as a designer. The proof of this is traditionally supposed to be the

16, 17 campanile of Florence Cathedral.

All this led, in the second half of the thirteenth century, to a further emphasis on the division between the office and the shop floor. There is a famous thirteenth-century sermon in which the preacher described workshops in which 'it was the custom to have a principal master who gave only oral orders, was very rarely on the job or never used his hands, although he received a much larger salary than the others. . . . The masters of the masons, carrying a rod and gloves, ordered others to "cut it for me there" and worked not at all, although they received a larger payment.' This is part of a tendency on the part of architects within the bounds of their own competence to emphasize the 'scientific' or 'intellectual' aspects of their occupation at the expense of the 'art' in its medieval sense of craft.

That one of the arts should have been feeling its way towards intellectual respectability in the second half of the thirteenth century is interesting because, of course, in the end, and in their own way, the other arts followed suit in the fourteenth and fifteenth centuries.

55 Stained glass at Bourges, c. 1220. The roundel shows the story of Dives and Lazarus; the quatrefoil, masons at work. Stained-glass artists were in a sense the rivals of architects, since the rich dark colours, where the glass survives complete, make it difficult to see the structure

56, 57 Growing lightness. At the
beginning of the thirteenth century
(*above*, Chartres) the windows are
relatively small, the plate tracery
heavy, the triforium opaque, the
glass heavily coloured. By the end
(*right*, Beauvais) the windows, with
their bar-tracery, cover almost the
whole wall, including the now
transparent triforium. The glass is
now much more sparingly coloured

58, 59 Between the twelfth and the fourteenth centuries the over-all control of the architect increased, giving buildings a greater unity but often reducing the interest of their separate parts. The choir of Canterbury (*left*), by William of Sens and William the Englishman, was the result of collective effort by masons, sculptors and stained-glass workers. The nave (*right*) by Henry Yevele, gives a much stronger impression of a design controlled by a single intelligence

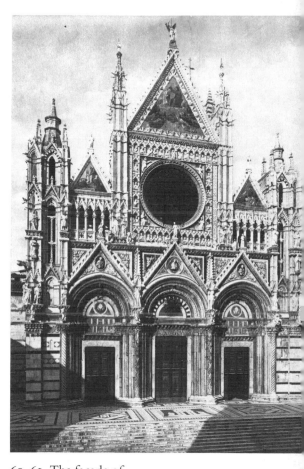

60, 61 The façade of
Siena Cathedral offers a
significant contrast to that
of Orvieto. Designed for
much of its height by
Giovanni Pisano it
provides a setting for his
weighty, life–size,
gesticulating figures

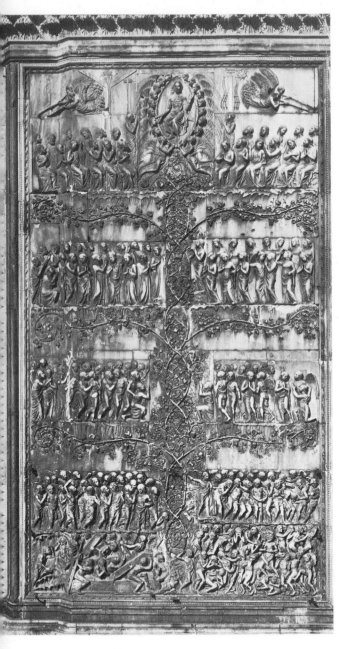

62, 63 Orvieto Cathedral,
by Lorenzo Maitani.
Unlike Giovanni Pisano,
Maitani was probably not
a sculptor, and his façade
has a strong 'drawing-
board' quality. In fact, he
designed a flat surface for
pictures in stone and
mosaic, not a composition
in depth. *Left:* the right-
hand section of reliefs,
showing the Last
Judgment

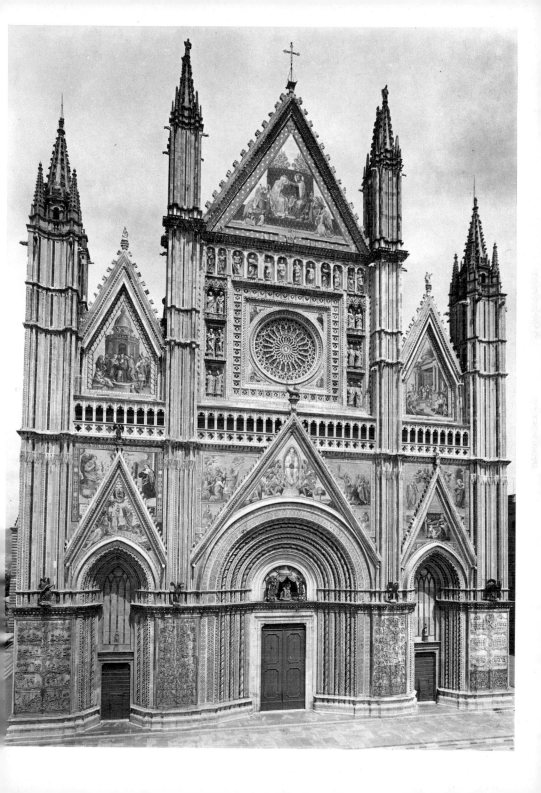

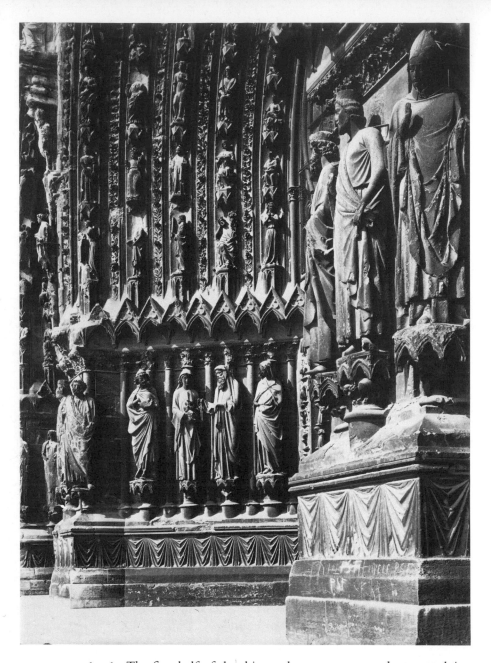

64, 65 The first half of the thirteenth century saw sculpture evolving from a position of subordination to architecture, as on the west portals of Chartres, to one in which architecture became merely its setting. The process is beginning at Rheims (*above*) where the figures relate to each other independently of the building, and is virtually complete at Naumburg where, for instance, Hermann and Reglind (*right*) are living characters in their own right

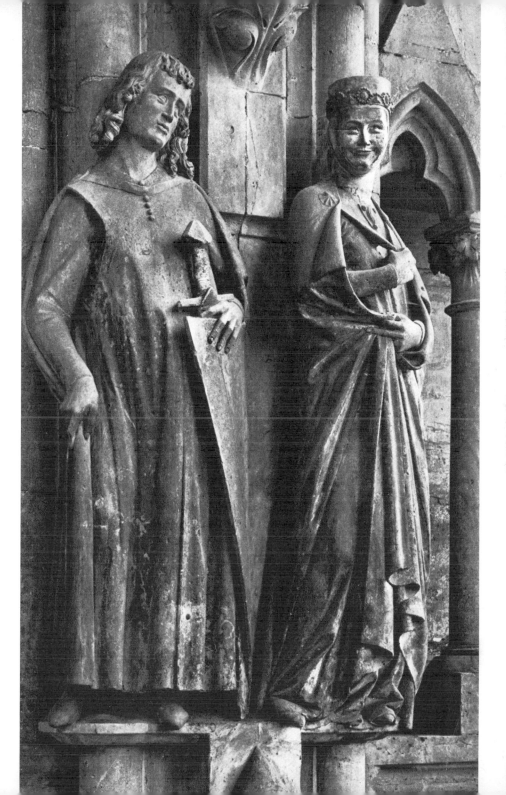

66 The architect as master-mind: Brunelleschi's Pazzi Chapel is designed as a complete entity to which nothing could be added – the culmination of a tendency already present in the late Middle Ages

Artists and the Renaissance

The anonymity of medieval art has been a frequent source of speculation and it has in general been contrasted with the highly personal achievements of the great artists of the Italian Renaissance. From this, a further familiar contrast had been reached between the Medieval Artist and the Renaissance Artist, the general tenor of which is that during the fifteenth and sixteenth centuries in Italy the artist in some way emerged as an individual. It is as if artists, as a species, underwent some fundamental change in response to the new humanist ideas current in fifteenth-century Florence and elsewhere in Italy. Whatever considerations may prompt it, the idea of the New Model Artist of the Renaissance should be subjected to critical examination. Not least, it is a concept which places medieval artists historically at a permanent disadvantage and makes them all too easily represent attributes the opposite of those of the supposed Renaissance Artist. Where he stands for individuality, his medieval forebear comes to embody anonymity; modernity is contrasted to archaism, progressiveness to retrogressiveness, and so on.

A comparison of the works themselves casts doubt on the supposition. The surviving works of Claus Sluter at the Chartreuse de Champmol represent the output of about a decade of his life. Is it possible to say that they are in some way a less 'individual' achievement than the works of Donatello when he was about the same age? This would mean divining some fundamental distinction separating Sluter's so-called *Puits de Moïse* from Donatello's figures 74
on the Florentine Campanile. Similar comparisons spring to mind. 73
Why should it be supposed that Gislebertus, the stupendous twelfth- 68
century sculptor of the Cathedral of Autun, was less of an individual
personality than Ghiberti? 67

There is, of course, a simple answer to this. As it happens we know a considerable amount about Ghiberti's personality because

67, 68 The myth of anonymity. Gislebertus of Autun was no less of a personality than Ghiberti, and was equally anxious that his name should be remembered. He left it on the tympanum beneath Christ's feet (*right*), just as Ghiberti left his portrait on the Baptistery doors in Florence (*left*)

historical record survives, whereas nothing is known about Gislebertus. The same is true about Donatello in contrast to Claus Sluter. This is a direct result of the Italian Renaissance. Record was made because, at this time and place in history, art ceased to be merely a craft or a trade and became the object of intelligent interest to educated and articulate men.

It was remarked earlier that there is no evidence for any of the *mystique* of the Great Artist in the Middle Ages. There is, in fact, little evidence for an informed interest in the arts by non-artists at all. Nothing is, indeed, more striking than the apparent apathy towards art. Monastic writers practically never supply any form of objective comment on the careers of men who furnished their houses with illuminated books or enriched their churches with 47 sculpture. Matthew Paris, himself an artist, took an interest in the decoration of his own monastery, St Albans, and (quite exceptionally) provided a list of the works of one of the painters. Most medieval writers were content to do no more than to record a name here and there. Where artists are the subject of stories, the tone is not usually one of awed wonder. There is, for instance, the story (recorded in the fifteenth-century collection of Robert Capgrave) of the twelfth-century painter who, commissioned to decorate the chapel of St Erconwald in St Paul's Cathedral, London, unwisely refused to stop work on St Erconwald's Day and locked the entrance against those who came to worship at the Saint's shrine. It

98

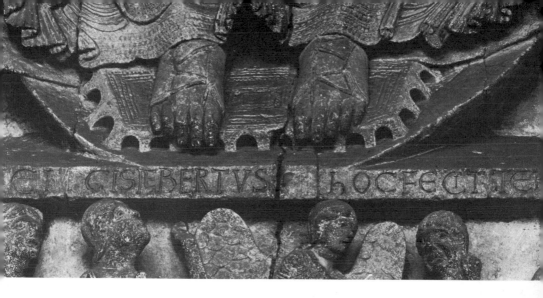

no longer seems strange to us that Michelangelo should have wanted to lock himself up in the Sistine Chapel while he was working there. The legend, however, was not so kind to the London painter. For, 'while he was carefully laying out his colours, he was suddenly robbed of all strength and seized by a sudden affliction so that he fell to the ground as if dead. When he had been thus tortured for a long time, behold the aforesaid bishop appeared, arrayed in episcopal robes and beat him sorely with his episcopal staff, recounting his negligence that he should stubbornly have persisted in working on that day and should have shut the people out. This vision and beating the painter recounted to many people after he had recovered from that infirmity.' In fact, stories involving artists are very rare and seldom complimentary.

The development that has been described, by which artists entered the chamber of a king or duke in an official capacity, was really a very remarkable one. These men had in fact risen as high in medieval society as it was possible for a non-noble layman to go. Yet, if the reasons for this preferment were not primarily professional ones (as we have suggested), it is easy to see how this development had little, if any, immediate effect on the esteem in which art as an occupation was held. The non-professional aspect of the artists and *valets de chambre* seldom emerges into the light of history. We may see it in Jack of St Albans dancing on the table before Edward II (although Jack is not known to have been a

servant of the chamber). We may see it, too, in the joke-book presented by the Limbourg brothers as a New Year's present to the duc de Berry; and again in the confidential missions executed by Jan van Eyck for the Duke of Burgundy. What may seem clear from the extremely slender evidence is that activity of this sort might advance the artist as a man but could not necessarily do much to advance the status of his occupation.

And yet, perhaps surprisingly, this type of advancement proved absolutely crucial. In particular, it was the career of Giotto that appears to be important. Giotto had a well-known and extensive public career. He moved round Italy in the service of the rich and the mighty. It was even alleged that he went to Avignon, although this now seems doubtful. He was himself wealthy. He was known to and mentioned by Dante – which meant that all the Dante commentators were obliged to write footnotes explaining who he was. Finally, because of his career, he was included in a book about famous men – to be precise, Filippo Villani's *De Origine civitatis Florentiae et eiusdem famosis civibus* of 1381–82.

18, 14 Giotto's career was not so very different from that of Simone
38 Martini; and his position *vis-à-vis* the King of Naples was certainly
25 comparable to that of Girart d'Orléans *vis-à-vis* the King of France. The professional horizons of the artist were widening during the fourteenth century; and Villani's decision to include Giotto and other artists (including sculptors) in the ranks of famous men was made against this background.

The attitude was, however, strengthened by various elements to be found in the early stages of the development of humanism. Early humanist scholars were particularly concerned with the revival of the language and rhetoric of the age of Cicero. The texts with which they were familiar made frequent play with the names and
85 achievements of the great Greek artists of the fifth and fourth centuries BC. This was chiefly done by way of analogy. Art was called in to lend force to points made about language and literature. But there was one major text – the *Natural History* of Pliny the Elder – which contained a vast and collected mass of information about these men. These texts promoted two key ideas. First, that art was capable of sustaining a sophisticated critical vocabulary; second, that art was capable of supporting a history of itself. There were further ideas buried in the texts for those who wanted to dig

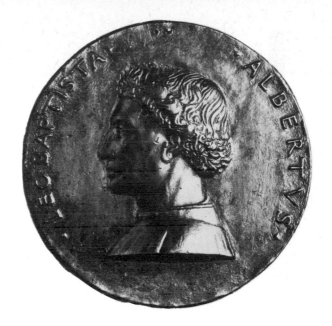

69 Leonbattista Alberti expressed the humanist view of the artist as an educated all-rounder and a gentleman. The medal is by Matteo de' Pasti

– for instance, the idea that the best artists are intelligent educated people, who know about things like mathematics and geometry.

All these ideas were raised during the first century of the humanist revival. It is clear that no coherent view existed about what to do with them all. But two quite interesting images of the artist appeared towards the middle of the fifteenth century. One of them, to be found in the opening pages of Ghiberti's *Commentarii* (probably written *c.* 1430–50) suggests an intellectual power-house of formidable proportions. Treading heavily in the footsteps of Vitruvius, Ghiberti suggested that the first-rate artist should be versed in Grammar, Geometry, Philosophy, Medicine, Astrology, History, Anatomy and Arithmetic. This is clearly nonsense and it was not repeated. But the key idea was, of course, that the artist in his training shared certain things with other reasonable educated men. The picture painted by Alberti in his *De Pictura* (*c.* 1435) is far more plausible. He too emphasizes that the best artists are educated. But he also says they should be reasonable and likeable men who get on well with other people (especially, of course, princes). They should also cultivate the acquaintance of poets and orators. All of that sounds very similar to the careers of Giotto and Simone Martini. In fact, the Renaissance 'Rise of the Artist' seems

67

69

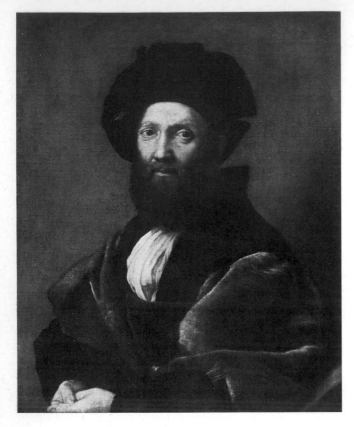

70 Castiglione's *Courtier*, written during the early sixteenth century, gives a vivid picture of the artist's status at that time; his new dignity was still somewhat precocious, depending as much on classical texts as on real respect for his work. Raphael, the painter of this portrait of Castiglione, made acceptance easier by being an accomplished courtier as well

to depend on the events of the previous century. It was true also of the courtier-artists of the North; and it continued to be true of men like Pisanello and Jan van Eyck.

40, 41

The pressure of reality was extremely important because there were far less favourable attitudes to artists buried in the literature of antiquity. In a passage in Plutarch's *Lives* Alexander the Great forcibly puts the view that admiration of a work of art does not necessarily lead one to esteem the person who created it. Pliny the Elder, while admiring the giants of the past, gets noticeably less enthusiastic, the nearer one gets to his own time. In fact, his view of contemporary art was that it was vulgar and impoverished. These hostile attitudes were never, apparently, revived during the Renaissance – and, once again, it was what artists had already achieved that made this impossible.

For all that, a certain amount of prejudice against artists survived in polite circles. This is well illustrated in *The Courtier* of Castiglione. 70 This book, planned in about 1508 and written and published during the following two decades, purports to record a series of conversations which took place at the court of Urbino in which the qualities of the ideal courtier were discussed. Its interest here lies in the fact that the status of the arts came in for consideration. The traditional prejudice against the arts is reiterated but Castiglione also shows how this prejudice was overcome. At one point, one of the speakers is made to put forward the idea that the courtier should know how to draw. 'Nor', he adds, 'are you to be surprised that I should suggest this quality which today may seem mechanical and hardly appropriate to a gentleman. Yet I remember having read that the ancients, especially throughout Greece, desired that noble children should be set to work at painting in the schools as a thing both wholesome, honest and necessary and this occupation was afforded a high place among the liberal arts. For it was forbidden by public order that it should be taught to slaves.' The ensuing conversation is extremely interesting because it indicates the terms on which polite society now talked about the arts. The rehabilitation depended almost exclusively on admiration for sentiments and actions recorded in antique texts, and it was largely by dwelling on these that courtly society was able to convince itself that there might be honour among artists. Thus, in mopping up these pockets of resistance, the chief ammunition – heavy and mainly effective – was Classical literature. But it was only effective because the artists had themselves narrowed the credibility gap between the two images of themselves as city craftsmen and as 'near-gentlemen.' Moreover, this area of propaganda could only be effective because of the compelling fascination of Classical antiquity, as polite fashion followed in the wake of humanist enthusiasm. The texts of Vitruvius and Pliny, upon which most of the new attitude to art was based, existed during the Middle Ages in monastic libraries, but few people can have bothered to read them. Only rarely does the name of an antique painter emerge, as when the twelfth-century Gerald of Wales in one of his prefaces unexpectedly alludes to the Greek painter Zeuxis. But it was first in fifteenth-century Italy 85 that men were prepared to take the anecdotes of Pliny seriously and to comment, for instance, with approval and admiration, on the

71 Part of the signed sculpture by Wiligelmo on the west front of Modena, *c.* 1099–1106; the creation of Eve and the expulsion from Paradise

way in which Alexander was said to have treated his painter Apelles. It is this sort of thing which was seriously discussed by Castiglione's courtiers in a way which one cannot imagine happening at the court of the duc de Berry. The new dignity acquired by the artists was to a large extent a dignity borrowed from antiquity.

It would be interesting if one could trace the development of this dignity. To some extent, it should have been reflected in the public and private honours offered to artists. In this respect, it is of interest that in the fifteenth century Mantegna, Crivelli and Gentile Bellini were all created knights. In addition, Gentile Bellini was made a Count Palatine. This is not the place to examine precisely what this meant, although the evidence shows that while in the fourteenth century these honours were reasonably rare, by the late fifteenth century they were becoming embarrassingly common. More interesting is the appointment of the Italian painter

104

Rosso (*c.* 1535) to a lay-canonry in the Sainte-Chapelle, Paris; and
also the rumour (untrue) reported by the Venetian Lodovico Dolce
that Raphael was made a papal Chamberlain at the end of his life. *70*
Rosso's appointment brought the artist up to the equivalent status
of Petrarch's chaplaincy. Raphael's would have transcended
the status of *valet-de-chambre* previously attached to artists. Perhaps
one should not attach too much importance to these labels. But
they have some value as general direction-indicators.

The result of this whole movement is an increased awareness
of the individual achievements of artists of the Italian Renaissance.
Yet nobody seriously believes that Renaissance artists were alone
in taking pride in their work and individuality. If proof were
required to the contrary, one has only to consider the act of inscrib-
ing personal names on finished works. This practice was followed
in Europe irregularly even during the Renaissance. But it can be
traced back at least to the twelfth century. It was a practice par-
ticularly common in Italy, but examples can be found north of the
Alps. The main difference lies in the fact that the Italian inscriptions
are often notably longer and openly self-laudatory. Gislebertus
of Autun (*c.* 1130) was content to inscribe his *chef-d'œuvre* with the *68*
words *Gislebertus hoc fecit*, whereas at Modena, a little earlier, the *71*
mason-sculptor Wiligelmo added to a dedicatory inscription the
following Latin couplet:

> *Inter scultores quanto sis dignus onores*
> *Claret scultura nunc Wiligelme tua.*
> (Among sculptors, your work now shines forth, O Wiligelmo,
> to show how greatly you are worthy of honours!)

This type of inscription reached a climax in Tuscany in the
second half of the thirteenth and early fourteenth centuries. A
notable series adorns the work of Nicola Pisano and of his son
Giovanni. The most curious is on the pulpit in Pisa Cathedral, put *72*
up by Giovanni in the first decade of the fourteenth century. It is
far too long to be quoted in full; moreover, the indifferent Latin
in which it is couched – a type of verse containing internal rhymes
within each line – is frequently obscure in its meaning. Its estimation
of the skill of Giovanni, however, is not in the least obscure. 'He
would not know how to carve horrid or unseemly things even if
he wished to do so' and 'he is endowed above all others in the

ordering of the pure art of sculpture' are representative sentiments. Their first effect now is to raise a smile to the lips, but they bring out clearly how much medieval artists could feel the individual merit of their creations and how greatly they cared about leaving permanent record of the creator's name.

It is even possible to sketch out the career of a medieval *uomo universale* – that is, an artist with the ability, much admired in the Renaissance, to practise in all three arts of painting, sculpture and architecture. Such a man seems to have been the Fleming André Beauneveu. First mentioned as a sculptor at Valenciennes in 1361, he was paid for paintings in the Town Hall there in 1374. In 1364 he was working as a sculptor for Charles V of France, and by 1390 was in the employment of the duc de Berry, for whom he also executed miniature paintings. Apart from these duties he was also as a mason called in to advise on architectural problems at Valenciennes in 1363 and probably at Cambrai in 1378.

It would be misleading, therefore, to suppose that medieval artists were essentially different creatures from those of the Renaissance. Yet it is impossible to instil a personal role into most medieval art history because of the limitations of the sources. Much outstanding work is condemned to remain for all time anonymous; many artists who were eminent in their time are probably condemned to remain as mere names without known works; and motives and attitudes will remain a matter of reasonable conjecture. We can, for instance, conjecture that the painter who offended St Erconwald wished to lock himself in, undisturbed, for the same reasons as Michelangelo when he was working in the Sistine Chapel. But if, for many people, medieval studies appear to be dry and depersonalized, the fault lies in the records and not in the artists. In spite of such disadvantages, it is still possible to build up a picture of medieval artists as industrious, useful and, more especially, human members of the community.

72 The long inscription running round the Pisa pulpit by Giovanni Pisano below the level of the reliefs and round the base bears witness to the pride which one medieval artist certainly felt in creating a masterpiece

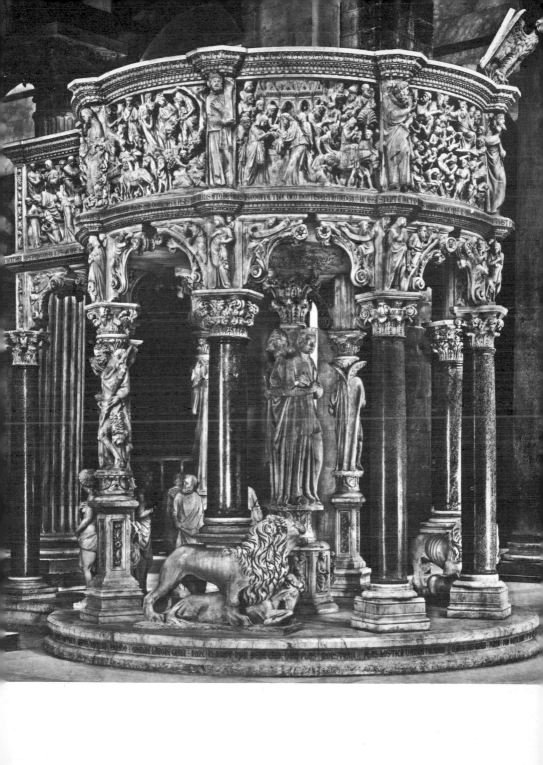

73, 74 False antithesis.
Above: Donatello's
Habakkuk ('*il Zuccone*').
Right: Claus Sluter's
Daniel and Isaiah. One
'Renaissance', the other
'medieval'; both, direct
expressions of strong
personalities

atrem in
uocabitis
qui terram
fecit et condidit celos.

e pere vous
apteres qui
a fet le chiel
et la terre.

75, 76 The medieval *uomo universale*. André Beauneveu seems to have been equally adept at painting, sculpture, architecture and stained-glass design. *Left:* miniature of Jeremiah from a Psalter by Beauneveu. *Above:* his effigy for the tomb of King Charles V at Saint-Denis

77, 78, 79 It was normal practice for medieval artists to keep sketchbooks containing observations of their own and copies of designs by others. *Left:* a page from an English book of about 1400, showing peacocks, a rook and other birds. *Right:* sketch of dogs attacking a boar, by Giovannino de' Grassi, probably made between 1380 and 1390. *Below:* detail from the 'December' page of the *Très Riches Heures* (1413–16) – the same design, probably borrowed not from Giovannino but from a source common to them both

80 *Overleaf:* two studies of a horse's head by Pisanello, evidently from life

81 Another drawing from the sketchbook of Giovannino de' Grassi: boatmen hoisting a sail

Postscript

When this book first appeared, it was as part of the larger *Flowering of the Middle Ages*. That volume came under fire from a distinguished reviewer for being, in effect, too glossy. He said that the general impression was of a 'highly idealized vision of medieval society' and of a 'static environment'. The book, moreover, failed to give a true picture of 'the basic instability – in men's souls as well as in the surrounding world – which set in after the Black Death'. I have frequently thought about this, partly because the accusation that the contributors gave too 'static' a picture of the Middle Ages seemed to me an unjust one. I should agree that the book itself gave a static impression, although for rather different reasons to which I shall return. But I am not, in any case, clear that this characterization of the later Middle Ages as being in some sense a more unpleasant period to live in than the earlier Middle Ages is either true or useful. Times change and every age has its own problems. The most remarkable thing is the resilience with which most people learn to live with these problems. If this were not so, one would be left with the conclusion that in some deep sense it would have been more satisfying to paint under Henry II of England than under Philip the Good of Burgundy. This is hard to believe.

Illustrated books about the Middle Ages tend to look glossy. This is the fault of the artists; and to the extent that I originally had the artists under my protection, I feel under some obligation to reply on their behalf to the accusation that they have failed to reveal to us what we think life was like when they were alive. First, then, if we are in any doubt that they pondered the problems of pain, mutilation, despair, anguish and so on, these doubts might have been dispelled by an anthology of representations of the Massacre of the Innocents and the Passion scenes. It would be much harder (incidentally, for almost any period) to document via art the less catastrophic disadvantages of human existence. Dirt, squalor,

boredom or frustration have, on the whole, lain outside the province of art before the nineteenth century. The nearest medieval equiva-
82 lents to the kitchen sink are the brass utensils of Robert Campin;
83 the nearest thing to squalor in this book is Hildebert's picture of himself throwing something at an intrusive mouse.

The reasons for this are not especially complicated. For one thing, dirt and squalor as matters of general concern are discoveries of the nineteenth century. But, at a deeper level, it is also true that the unquestioned purpose of medieval artists was twofold; it was to instruct and it was to please. This last expression is perhaps ill-
86 chosen. One may doubt whether the Pantocrator at Cefalù is aimed precisely at pleasing. That the artist was concerned with beauty, however, we cannot doubt. This idea was firmly rooted; and it is no surprise that it emerges as a firm preoccupation in the earliest formulations of critical theory in about 1400. It is the con-
69 cern both of Cennino Cennini and Leonbattista Alberti. Neither is it surprising that the early humanists revived the Classical discussion on the transforming effect that artists can have when they paint objects or experiences which would normally be considered distasteful. Most of the illustrations in this book are of works by extremely competent artists. They are highly professional creations

82, 83 Medieval realism. *Left:* detail of the *Merode Altarpiece* by Robert Campin, *c.* 1425–28, showing a realistic water-pot. *Right:* working conditions in a twelfth-century scriptorium. Hildebert throws a sponge at a large mouse eating a piece of cheese. His actual words are written in the book in front of him: 'Wretched mouse, provoking me so often to anger; may God bring you to perdition.' In the foreground his assistant Everwinus practises a 'clove curl'

and do not, least of all at a technical level, exhibit doubts or confusion. But more than this, they demonstrate with absolute clarity the conviction which the best artists felt, that part of their job was to transform and to create a thing of beauty.

For this reason, it is probably wrong to expect medieval art to provide an adequate reflection of medieval living conditions. To me, at least, paintings dwelling on twentieth-century living and working conditions are boring enough, and it would seem charitable not to wish the same sort of tedium on the Middle Ages. But this is not the real core of the problem. That art reflects the age in which it was produced is a truism of the most exasperatingly imprecise sort. It normally means, in any case, that one will read into the art whatever preconceptions one has about the period. But every work of art is a unique creation by an individual in a particular set of circumstances. Few art historians would deny that the more one knows about the most accomplished works of art, the more individual they become. Those general characteristics which may seem to make them a product of their time become less pronounced; those which provide the particular individuality become more so. Moreover, because mankind is almost infinitely varied, every age will provide almost as many contrasts as comparisons.

To cite a particular example, one might turn to hospital altar-pieces. In a medieval hospital, the main altar was set in the ward itself and the altarpiece, therefore, formed a focal point. This was what men *in extremis* gazed at; and the contents must reflect what were supposed to be the hopes and aspirations of their last failing moments. As far as these survive, it is not difficult to find examples where one would immediately diagnose 'late medieval uncertainty'.

88 Roger van der Weyden's Beaune altar (*c.* 1450) is a Last Judgment painted on an unprecedented scale and conveying the terrors of
89 Hell in stark and uncompromising detail. Grünewald's Isenheim altar (*c.* 1510) contains one of the most grotesque and horrifying representations of the crucified Christ ever painted. But if these are characteristically 'late medieval', what is one to make of the
90 altar painted by Memlinc in 1479 for the Hospital of St John at Bruges? The answer is clear. The detached calm and total certainty
86 of this altar must also be 'late medieval'. Similarly, the Cefalù
87 Pantocrator and Gislebertus's Autun *Last Judgment* are equally of the twelfth century. Matthew Paris and the artist of the Goslar Evangeliary are equally of the thirteenth century.

To me, at least, there seem to be many snares laid for those who seek to draw general conclusions about medieval society from individual works of art. An individual work illustrates in itself no more than a tiny highly specialized part of its age; no single work is going to reflect anything very useful; and in order to get nearer to the truth, the least that one can do is to assemble as many examples of the art as possible. Moreover, these examples should represent the range of available commissions, the range of available subject-matter, the range of response to this subject-matter and, probably too, the range of artistic competence. The fifteenth century will not be adequately represented by yet more reproductions of the *Très Riches Heures* of the duc de Berry. Now it is arguable that large illustrated works such as the *Flowering of the Middle Ages* fulfil a part of these aims. They seldom err in terms of quantity; and for the most part the quality of available art during the relevant period is adequately conveyed. Their most common failing is that art is used in an illustrative role. This means that it is thrown together in a great jumble of periods and styles with the sole aim of illustrating the discussion of the moment. The art is, as it were, projected at the spectator like a gigantic charge from some

heavenly blunderbuss. The result is magnificent, not to say devastating. But it has its disadvantages, the chief being that it is unhistorical.

The study of the history of art, like all historical studies, has its own *raison d'être*; but it also performs several other important functions. At the least, it can provide the right visual context for the imaginative reconstructions of historical events. It will save the ecclesiastical historian from the anachronism of imagining Peter Abelard standing in a *rayonnant* cathedral. It will save the political historian from imagining King John of England dressed in a *houpelande*. But this type of adjustment is probably seldom necessary. One of the simplest but most profound lessons of history is that things change. Art is one of the surest reminders of this truth. Stylistic change may sometimes seem as swift as a *coup d'état* or alternatively as slow as administrative reform, but the element of change is always present. Thus, although nobody seriously believes the Middle Ages to have been static, art provides a permanent testimony that they were not. The changes studied by the art historian run alongside the other subjects of historical study, underlining, if necessary, the gulf separating, for instance, the Age of Reform from the Conciliar Epoch or the world of Charlemagne from that of William the Conqueror. But if this point is to be conveyed, the first essential is that the art must be set out as far as possible in the right chronological order. Large illustrated books on general themes cannot or do not always do this. But where artistic styles and periods are mixed together indiscriminately, the result will tend to destroy any impression either of continuity or of change. Instead, the visual material will congeal into an inseparable mass and become static. It will cease to be history; and in any book dealing with historical themes, this is a pity.

To some extent, this book also falls into the trap. It is not a work of stylistic analysis or history and, in any case, its main accent lies on a comparatively restricted period between *c.* 1300 and *c.* 1450. Nevertheless, it does, I hope, give a picture of artists as a series of reasonably responsible and interesting individuals. Their lives, incidentally, do not suggest that the uncertainties of medieval existence weighed particularly heavily on them. Of all medieval hazards, the most considerable (at least in the later Middle Ages) was probably the bubonic plague. This probably disposed of the *84*

Lorenzetti brothers in 1348, the Limbourg brothers in 1416, Masaccio in 1428, Giorgione in 1510 – and the list could doubtless be extended. But records of other major artists coming to untimely ends through chance or violence are few. William of Sens was permanently crippled as the result of a fall from some scaffolding (but this is as much a twentieth-century hazard). Mostly, the artists that we know about seemed to have lived for a respectable period (by pre-nineteenth-century standards); to have avoided battles and civil disturbances (Coppo di Marcovaldo is the only artist known to me who fought in a battle and he became a prisoner-of-war); and to have avoided prison, although not, of course, litigation. Many of them were wealthy and moved in what may be described as 'the best circles'. I have no doubt that Giotto lived a long, useful and interesting life; and in his own terms enjoyed himself as much, *mutatis mutandis*, as Sir George Gilbert Scott.

84 Artists, like the rest of society, lived under the threat of bubonic plague. Some died of it, among them probably the Limbourg brothers, who had added this little scene of a procession against the plague to a Book of Hours painted in the early fifteenth century

85 Polite society visits a painter's studio at Ghent. The story is that of Zeuxis composing his ideal woman from several models, the setting is fifteenth-century Flanders

86, 87 'Medieval' means not one style but many. The hieratic stillness
of Christ Pantocrator at Cefalù (*above*) and the terrifying emotion of
Gislebertus's Last Judgment at Autun (*right*) are equally of the twelfth
century

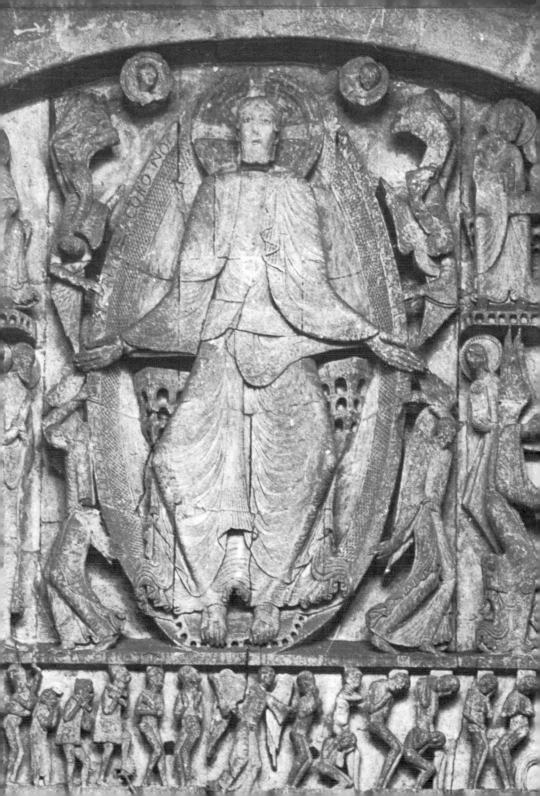

88, 89 'Late medieval' can characteristically include the horrors of
Roger van der Weyden's Hell (*left*) and of Grünewald's Isenheim altar
(*above*). But no less typical is the calm certainty of Memlinc (*see overleaf*)

90 Memlinc's Virgin and
Child with Saints is an
altarpiece painted, like
those of Roger and
Grünewald on the
previous page, for a
hospital. All three belong
to the years 1450 to 1510,
so all are 'late medieval'.
Yet Memlinc's vision is
one of untroubled peace,
of radiant, beatific faith

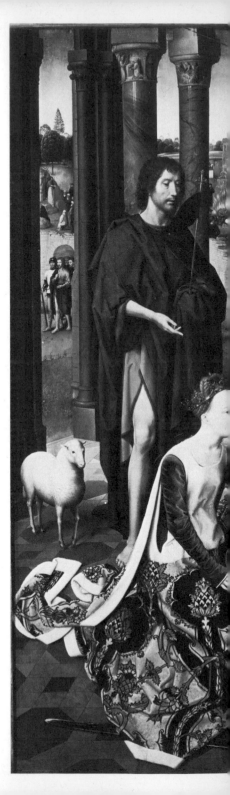

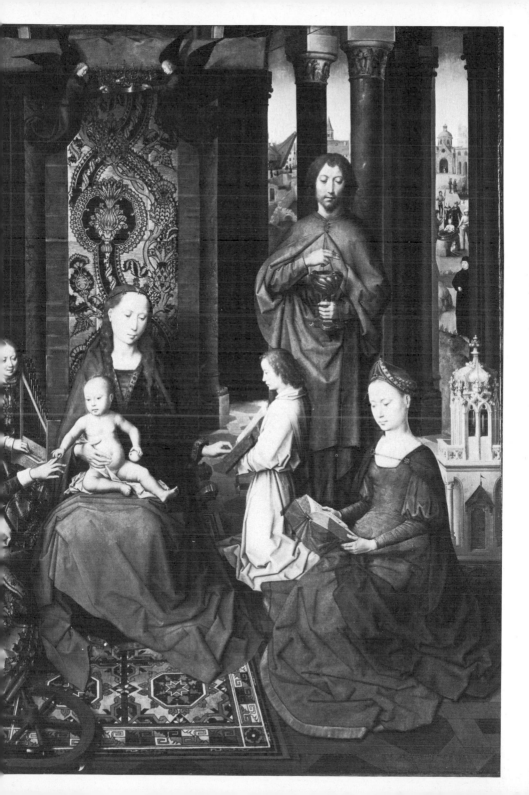

Bibliographical Note

I know of no general books covering this subject, although parts of it (for instance that part concerned with the impact of early humanist thought) have obviously been treated extensively by previous writers. The core of the argument rests on numerous printed original sources and the bibliography which follows aims to list these sources for the benefit of anyone interested in following up any of the points.

There are various general collections of texts which will form a useful starting-point for anyone wishing to get a general impression of medieval writing about art. Four of the largest are:

V. MORTET, *Recueil de textes relatifs à l'histoire de l'architecture et à la condition des architectes en France au moyen âge XI^e–XII^e siècles* (Paris 1911–29)

O. LEHMANN-BROCKHAUS, *Lateinische Schriftquellen zur Kunst in England, Wales und Schottland vom Jahre 901 bis zum Jahre 1307* (Munich 1955–60)

C. C. A. DEHAISNES, *Documents et extraits divers concernant l'art dans la Flandre, l'Artois et le Hainaut avant le XV^e siècle* (Lille 1886)

G. MILANESI, *Documenti per la storia dell'arte Senese* (Siena 1854–56)

All of these are highly specialized and reproduce the texts in the original languages. Two more recent and rather different collections of translated texts and documents should be noted:

E. G. HOLT, *A Documentary History of Art*, vol. 1 (New York 1957)

T. G. FRISCH, *Gothic Art 1140–c. 1450* (New Jersey 1971)

In addition, L. F. SALZMAN, *Building in England down to 1540* (Oxford 1952) has a useful appendix of translated texts dealing with English architecture. The whole field of literature was reviewed by J. VON

SCHLOSSER, *La Letteratura Artistica* (first ed. 1935; reprinted and revised Florence and Vienna 1964). VIRGINIA WYLIE EGBERT's valuable work *The Mediaeval Artist at Work* (1967) has already been noted.

I The Artist in Town and City

For the *Tractatus* of Jean de Jandun see LE ROUX DE LINCY and L. M. TISSERAND, *Paris et ses historiens aux XIVe et XVe siècles* (1866)

The 1292 *Taille* Assessment is printed in P. H. J. F. GÉRAUD, *Paris sous Philippe le Bel* (Paris 1837). For the various guild ordinances
(1) those for Siena were printed in MILANESI, *op. cit.*;
(2) for London, see W. A. D. ENGLEFIELD, *The History of the Painter-Stainer Company of London* (London 1923)
(3) for Florence (1339) and Padua (1441) see G. GAYE, *Corteggio Inedito d'Artisti dei Secoli XIV. XV. XVI.* (Florence 1839–40), vol. II
(4) for Venice, see G. MONTICOLO, *Nuovo Archivio Veneto*, vol. II (1891)
(5) for the Parisian statutes of 1391, see J. LEBER, J. B. SALGUES and J. COHEN, *Collection des Meilleures Dissertations, notices et traités particuliers relatifs à l'histoire de France* (Paris 1826–38), vol. 19

For the thirteenth-century series contained in *Le Livre des Métiers d'Étienne Boileau* see G. B. DEPPING (Editor), *Le Livre des Métiers d'Étienne Boileau, Documents Inédits sur l'Histoire de France* (Paris 1837)

References to Henri Mannin, France von der Wichterne and Jacques Cavael come from C. C. A. DEHAISNES, *Histoire de l'Art dans la Flandre, l'Artois et le Hainaut avant le XVe siècle* (Lille 1886). Also Beauneveu and Jean de Hasselt. Documents on the Lorenzetti brothers will be found in G. ROWLEY, *Ambrogio Lorenzetti* (Princeton 1958). For Simone Martini see G. CONTINI and M. C. GOZZOLI, *L'Opera Completa di Simone Martini* (Milan 1970). Documents about Jan van Eyck are printed in W. H. J. WEALE, *Hubert and Jan van Eyck* (London 1908). Note also a recent article by T. H. FEDER, *Art Bulletin* 1966, dealing with the documentary references to Robert Campin and Roger van der Weyden.

2 The Artist at Court

By far the best general account of the medieval patronage of one court, the English, is contained in R. ALLEN BROWN, H. M. COLVIN, A. J. TAYLOR, *The History of the King's Works* I–III (London 1963). On a far more restricted scale, A. DE CHAMPEAUX and P. GAUCHERY, *Les Travaux d'art exécutés pour Jean de France, duc de Berry* (Paris 1894) may also be consulted.

The composition of a medieval court can now only be reconstructed from the ordinances issued from time to time governing personnel and finance. For the French Court during the thirteenth and fourteenth centuries several are printed and will be found in J. LEBER *et al., op. cit.*; J. P. VON LUDEWIG, *Reliquiae Manuscriptorum omnis aevi Diplomatum ac Monumentorum*, vol. XII, Book I; E. MARTÈNE and U. DURAND, *Thesaurus Novus Anecdotorum* (Paris 1717), vol. I; and J. JUVENAL DES URSINS, *Histoire de Charles VI, Roy de France* (Paris 1653).

Documents relating to Giotto's stay in Naples are to be found in O. MORISANI, *Pittura del Trecento in Napoli* (Naples 1947). The references to Pietro Cavallini and Montano of Arezzo will also be found there. For Filippo Rusuti see B. PROST, *Gazette des Beaux-Arts* 35 (Pér. 2), 1887, 'Quelques Documents sur l'histoire des Arts en France'. Jack of St Albans makes his one and only appearance on f. 28r of the Society of Antiquaries MSS. 122 which happens to be an isolated volume of Chamber Accounts for 1325–26.

For the French artists, U. THIEME and F. BECKER, *Allgemeines Lexikon der Bildenden Künstler* (Leipzig 1907–50) gives reasonable summaries for the chief names. For the Orléans family see V. DUFOUR, *Une famille de Peintres Parisiens* (Paris, Chartres 1877). Also DUC D'AUMALE, *Miscellanies of the Philobiblon Society* (1855–56), 'Notes et Documents relatifs à Jean, Roi de France... en Angleterre'. B. PROST, as already cited above, contains further information. For Jean Coste see *Archives Historiques, Artistiques et Littéraires* II (1890–91). See B. PROST, *Gazette des Beaux-Arts* 7 (Pér. 3), 1892, pp. 349 ff, 'Un nouveau document sur Jean de Bruges' for documents on Jean Bandol, and for Henri Bellechose and Jean de Pestimen see B. PROST, *Gazette des Beaux-Arts* 6 (Pér. 3), 1891, 'Une Nouvelle Source de Documents sur les Artistes Dijonnais du XVe siècle'.

For Drouet de Dammartin and his family see A. DE CHAMPEAUX and P. GAUCHERY, *op. cit.* For all artists who worked during this period for the Duke of Burgundy, two books are essential – L. E. S. J. DE LABORDE, *Les Ducs de Bourgogne, Études sur les lettres, les arts, et l'industrie pendant le XV**siècle* (Paris 1849–52), and B. PROST, *Inventaires mobiliers et extraits des comptes des ducs de Bourgogne de la Maison de Valois 1363–1477* (Paris 1902–13). The articles cited by Prost in the *Gazette des Beaux-Arts* form part of a long series in which he published a large amount of miscellaneous original material.

The work which these patrons commissioned and/or owned can, for the most part, now only be reached through inventories. The French royal family was especially prolific both in the collection of objects and the compilation of inventories and the following works may be consulted.

General Inventories

J. M. J. GUIFFREY, *Inventaires de Jean, Duc de Berry (1401–1416)* (Paris 1894–96)

J. LABARTE, *Inventaire du mobilier de Charles V* (Paris 1879)

Books

L. DELISLE, *Recherches sur la Librairie de Charles V* (Paris 1907)

M. L. DOUET-D'ARCQ, *Inventaire de la Bibliothèque du Roi Charles VI 1423* (Paris 1867)

Plate

L. E. S. J. DE LABORDE, *Notice des Émaux, Bijoux et Objets Divers exposées dans les galeries du Musée du Louvre* (Paris 1852–53) (vol. II has the Inventory drawn up *c.* 1360–68 of the jewellery and plate of Louis, duc d'Anjou).

The account of the amusement arcade at Hesdin is printed in full in L. E. S. J. DE LABORDE, *Les Ducs de Bourgogne* . . . cited above.

3 The Artist in the Cloister

A general introduction will be found in R. E. SWARTWOUT, *The Monastic Craftsman* (Cambridge 1932), although this book now seems needlessly polemical in tone. Theophilus, *De diversis artibus,*

should also be looked at (edited with translation by C. R. Dodwell, Nelson's Medieval Texts 1961).

LEHMANN-BROCKHAUS, *op. cit.*, collected a vast amount of material on the subject of monastic art, and the information on St Albans will be found there.

Two major and very different accounts exist of building and decoration in progress in a monastery. One, by Gervase of Canterbury, is to be found, slightly abridged, in HOLT, FRISCH, and SALZMAN, *opera cit.* The other, by Abbot Suger of Saint Denis, is to be found, abridged, in HOLT and FRISCH. The best edition of this part of Suger's voluminous writing is E. PANOFSKY, *Abbot Suger on the Abbey Church of Saint Denis and its Art Treasures* (Princeton and London 1946).

4 The Architect

The conclusions of this section are based on style and they receive no explicit confirmation in documentary sources. Nevertheless, there is, cumulatively, more information about masons from the Middle Ages than any other group of artists. An early insight into their activities is to be found in the Chronicle of Gervase of Canterbury already mentioned. One of the features of this account is the conference of architects called after the Canterbury fire. These conferences were reasonably frequent events in the Middle Ages and, where the minutes and recommendations survive, they give a first-hand impression of the professionals talking about their calling and, occasionally, about each other. The major accounts are as follows:

(*a*) 1318 Expertise on Chartres Cathedral. This is translated in FRISCH, *op. cit.*

(*b*) 1321/22 Expertise on Siena Cathedral. See MILANESI, *op. cit.*

(*c*) 1333 Expertise on Siena Cathedral. MILANESI, *op. cit.*

(*d*) Late fourteenth- to early fifteenth-century expertise on Milan Cathedral. These deliberations ran on for many years and involved a large number of consultant architects. The best general account is by J. S. ACKERMANN, *Art Bulletin* XXXI–2 (1949) ' "Ars Sine Scientia Nihil Est", Gothic Theory of Architecture at the Cathedral of Milan'. Parts of the deliberations are also to be found in FRISCH, *op. cit.*

Note also the committee discussions surrounding the building of the Cathedral of Florence *c.* 1350–70 and analysed by H. SAALMAN, *Art Bulletin*, XLVI (1964), 'Santa Maria del Fiore: 1294–1418'.

5 Artists and the Renaissance

The best description of the impact of Early Renaissance thought on art and its appreciation is M. BAXANDALL, *Giotto and the Orators* (Oxford 1971). See also, J. LARNER, *History*, vol. LIV (1969): 'The Artist and the Intellectuals in Fourteenth Century Italy'. Many of the most important relevant classical texts are conveniently extracted and translated in J. J. POLLITT, *The Art of Greece 1400–31 BC* (New Jersey 1965). The most important text was the *Natural History* of Pliny the Elder. For this, with parallel translation and excellent introduction, see K. JEX-BLAKE and E. SELLERS, *The Elder Pliny's Chapters on the History of Art* (1896, reprinted Chicago 1968). See also VITRUVIUS, *De Architectura* (Loeb ed., London and Cambridge, Mass. 1962.)

Of the Renaissance texts, VILLANI's is printed with translation, along with further texts by BAXANDALL, *op. cit.* A translation of ALBERTI's *Della Pittura* was made by J. R. SPENCER, (London 1956). No complete translation of GHIBERTI's *Commentarii* exists but portions are cited by HOLT, *op. cit.* The best edition of the original text is J. SCHLOSSER, *Lorenzo Ghibertis Denkwürdigkeiten* (Berlin 1912). See also CENNINO CENNINI, *Il Libro d'Arte*, translated by D. V. Thompson Jnr. (Yale 1933, reprinted New York).

Capgrave's story is quoted in Lehmann-Brockhaus, *op. cit.*

On the status implied by the titles of Knight and Count Palatine, see MORONI, *Dizionario*. The grants of the title of Count Palatine can be traced in the imperial registers. Compare, for example, the grants of the fourteenth century (A. HUBER, *Die Regesten des Kaiserreichs unter Kaiser Karl IV 1346–1378*, Innsbruck 1877), with those of the early fifteenth century (W. ALTMANN, *Die Urkunden Kaiser Sigmunds 1410–1437*, Innsbruck 1896–1900).

The inscriptions on the Pisani pulpits are fully transcribed with translations in J. POPE-HENNESSY, *Italian Gothic Sculpture* (London 1955). Note that the Pisa Cathedral pulpit inscription is also translated with differences of interpretation in FRISCH, *op. cit.* See also M. AYRTON, *Giovanni Pisano* (London 1969).

List of Illustrations

1 Paris street showing a goldsmith's shop, detail of a miniature from *La Vie de St Denis*; French, 1317. MS. fr. 2091–2, f. 99. Bibliothèque Nationale, Paris

2 Self-portrait of the illuminator Hugo, marginal sketch from Jerome's *Commentary on Isaiah*; Anglo-Norman, *c.* 1100. MS. Bodl. 717, f. 287v. Curators of the Bodleian Library, Oxford

3 King dictating the law, detail of a page from Gratian's *Decretals*, with miniature by Master Honoré; French, before 1288. MS. Tours 558, f. 1. Bibliothèque Nationale, Paris

4 St Eligius as a goldsmith making a saddle, detail of a panel-painting; Italian, fourteenth century. Prado, Madrid. Photo Mas

5 The art of painting, relief attributed to Giotto, formerly on Florence Campanile; *c.* 1334–37. Opera del Duomo, Florence. Photo Mansell Collection

6 Tubalcain, or the art of metal-working, relief attributed to Andrea Pisano, formerly on Florence Campanile; *c.* 1334–37. Opera del Duomo, Florence. Photo Mansell-Alinari

7 Monumental masons with a patroness, miniature from the *Roman du Saint-Graal*; French, early fourteenth century. MS. Add. 10292, f. 55v. Courtesy the Trustees of the British Museum, London

8 Pygmalion and Galatea, miniature from the *Roman de la Rose*; French, *c.* 1470. MS. Douce 195, f. 149v. Curators of the Bodleian Library, Oxford

9 Preparation of colours, initial from Jacobus's *Omne bonum*; English, fourteenth century. MS. Roy. 6. E. IV, f. 329. Courtesy the Trustees of the British Museum, London

10 Decorators at work painting walls and statues ('the building of Solomon's house'), miniature from a *Bible historiale*; French, early fifteenth century. MS. 394, f. 145. Pierpont Morgan Library, New York

11 Humility, Pride, the sinner and the hypocrite, miniature by Master Honoré from *La Somme le Roy*; French, 1290. MS. Add. 54180, f. 97v. Courtesy the Trustees of the British Museum, London

12 St Luke painting the Virgin, miniature from *Hours of the Virgin* (use of Mâcon); French, late fifteenth century. MS. Add. 20694, f. 14. Courtesy the Trustees of the British Museum, London

13 *St Luke painting the Virgin*, detail of a painting by Roger van der Weyden; *c.* 1435. Courtesy the Museum of Fine Arts, Boston

14 Virgin and Child enthroned, detail of the *Maestà*, fresco by Simone Martini; 1315. Palazzo Pubblico, Siena. Photo Scala

15 Street scene in Siena, detail of *Good Government*, fresco by Ambrogio Lorenzetti; 1337–39. Palazzo Pubblico, Siena. Photo Scala

16 Spire and octagon, detail of the parchment elevation perhaps by Giotto of Florence Campanile; probably 1334–37. Opera del Duomo, Siena. Photo Grassi, Siena

17 Florence Campanile; founded 1334, completed by Francesco Talenti, *c.* 1350. Photo Arnold von Borsig

18 *Ognissanti Madonna* by Giotto; 1310. Uffizi Gallery, Florence. Photo Mansell

19 Right-hand wing of the *Champmol Altarpiece* (open), carved by Jacques de Baerze and gilded by Melchior Broederlam; made for the Chartreuse de Champmol near Dijon; *c.* 1391–99. Musée de Dijon. Photo R. Remy

20 *Presentation in the Temple*, and *Flight into Egypt*, right-hand wing of the *Champmol Altarpiece* (closed), painted by Melchior Broederlam; made for the Chartreuse de Champmol near Dijon; *c.* 1391–99. Musée de Dijon. Photo Scala

21 Annunciation, frontispiece to the *Hours of Jeanne d'Evreux*, miniature from the workshop of Jean Pucelle; French, between 1325 and 1328. The Metropolitan Museum of Art, New York, The Cloisters Collection, Purchase 1954

22 Emperor Charles IV of Bohemia, detail of the *Ex-Voto of Archbishop Jan Očko of Vlašim*, attributed to Master Theodoric; *c.* 1370. Narodni Galerie, Prague

23 *St Jerome*, tempera panel by Master Theodoric; 1357–67. Chapel of the Holy Cross, Karlstein Castle, Prague. Photo Narodni Galerie, Prague

24 Members of a royal court, miniature from Jacobus de Cessolis's *Le jeu des échecs moralisé*; French, third quarter of the fourteenth century. MS. G. 52, f. 1. Pierpont Morgan Library, New York, Glazier Collection

25 Portrait of Jean le Bon, probably by Girart d'Orléans; *c.* 1359. Louvre, Paris. Photo Giraudon

26 Philip the Good receiving the manuscript from Simon Nockart, miniature from Jacques de Guise's *Chroniques de Hainault*; Flemish, 1448. MS. 9242, f. 1. Bibliothèque Royale de Belgique, Brussels

27 Duc de Berry beginning a journey, miniature by the Limbourg brothers added to the *Petites Heures du duc de Berry*; French, early fifteenth century. MS. lat. 18014, f. 288v. Bibliothèque Nationale, Paris

28 *Martyrdom of St Denis* by Henri Bellechose; 1416. Louvre, Paris. Photo Giraudon

29 'Tantalus cup' surmounted by a bird, drawing from Villard d'Honnecourt's *Sketchbook*; *c.* 1225. MS. fr. 19093, f. 9. Bibliothèque Nationale, Paris

30 Modern diagram of the 'tantalus cup' of Villard d'Honnecourt. Drawn by Ian Mackenzie-Kerr

31 Richard II, detail from the left-hand panel of the *Wilton Diptych*; French or English, perhaps, *c.* 1395. Courtesy the Trustees of the National Gallery, London

32 Presentation of the duc de Berry to the Virgin by Saints Andrew and John the Baptist, miniature attributed to Jacquemart de Hesdin from the *Brussels Hours*; French, *c.* 1400–1410. MS. 11060–61, page 14. Bibliothèque Royale de Belgique, Brussels

33 Madonna and Child, drawing in a boxwood pattern-book attributed to Jacquemart de Hesdin; French, late fourteenth or early fifteenth century. MS. M. 346, f. 1v. Pierpont Morgan Library, New York

34 Angel sounding the Second Trumpet, detail of one of the *Apocalypse* tapestries designed by Jean Bandol and Nicolas de Bataille; French, *c.* 1379. Musée des Tapisseries, Angers. Photo Giraudon

35 Presentation of the manuscript to Charles V by Jean de Vaudetar, miniature by Jean Bandol inserted in the *Bible of Charles V*; French, 1372. Codex 10B23, frontispiece. Rijksmuseum Meermanno-Westreenianum, The Hague. Photo A. Frequin

36 Detail of the effigy of Jean, duc de Berry, by Jean de Cambrai; fifteenth century. Cathedral of Saint-Étienne, Bourges. Photo Archives Photographiques

37 Statue of Jeanne, duchesse de Berry, attributed to Guy de Dammartin, above the fireplace in the Great Hall of the Palais de Justice, Poitiers; *c.* 1385. Photo Bildarchiv Foto Marburg

38 Robert of Anjou, King of Naples, detail of a miniature from an *Address* by the town of Prato to Robert of Anjou; Italian, *c.* 1335–40. MS. Roy. 6. E. IX, f. 10v. Courtesy the Trustees of the British Museum, London

39 Two Apostles, detail of a fresco of the *Last Judgment* by Pietro Cavallini; *c.* 1290. Sta Cecilia in Trastevere, Rome. Photo Scala

40 *Madonna of the Chancellor Rolin* by Jan van Eyck; *c.* 1435. Louvre, Paris. Photo Giraudon

41 *Tymotheos* or *Leal Souvenir* by Jan van Eyck; 1432. Courtesy the Trustees of the National Gallery, London

42 *Transfiguration*, fresco by Fra Angelico in one of the cells in San Marco, Florence; *c.* 1437–45. Photo Scala

43 Self-portrait of the artist being saved, detail of a miniature of the Last Judgment by W. de Brailes from a Bible; English, *c.* 1230–50. MS. 330. Reproduced by permission of the Syndics of the Fitzwilliam Museum, Cambridge

44 Portrait of the scribe Eadwine, miniature at the end of the *Canterbury Psalter*; English, *c.* 1148–49. MS. R. 17.1, f. 283v. Reproduced by permission of the Master and Fellows of Trinity College, Cambridge

45 Brother William (artist of the *Apocalyptic Christ*), marginal drawing by Matthew Paris from the *Chronica Maiora*; English, mid thirteenth century. MS. 16, f. 67. Courtesy the Master and Fellows of Corpus Christi College, Cambridge. Photo Courtauld Institute

46 Self-portrait of Peter Vischer, statue on the shrine of St Sebaldus by Peter Vischer and his sons; German, 1508–19. Church of St Sebaldus, Nuremberg. Photo Martin Hürlimann

47 Madonna and Child with the artist prostrate at her feet, miniature by Matthew Paris, from *Historia Anglorum*; English, mid thirteenth century. MS. Roy. 14. C. VII, f. 6. Courtesy the Trustees of the British Museum, London

48 Benedictine monk painting a statuette of the Virgin, presumed self-portrait of the illuminator, miniature from the *Lambeth Apocalypse*; English, third quarter of the thirteenth century. MS. 209, f. 2v. Lambeth Palace Library, London. Photo John Freeman

49 Artist painting a shrine (centre) and the preparation of a book (in the roundels), frontispiece to St Ambrose's *Opera varia*; German, first half of the 12th century. MS. Patr. 5, f. 1v. Staatsbibliothek, Bamberg

50 Christ in Majesty with Evangelistic Beasts, miniature possibly by Master Hugo of Bury St Edmunds from the *Bury Bible*; English, twelfth century. MS. 2, f. 281v. Courtesy the Master and Fellows of Corpus Christi College, Cambridge. Photo Courtauld Institute

51 *Apocalyptic Christ*, drawing by Brother William, leaf in Matthew Paris's *Lives of the Offas*; English, thirteenth century. MS. Cott. Nero D. I, f. 156. Courtesy the Trustees of the British Museum, London

52 The art of building, relief attributed to Giotto or Andrea Pisano, formerly on Florence Campanile; *c.* 1334–37. Opera del Duomo, Florence. Photo Mansell Collection

53 Building the Tower of Babel, detail of a wall-painting in the Church of Saint-Savin-sur-Gartempe, Vienne; early twelfth century. Photo Archives Photographiques, Paris

54 Parchment design (never executed) for the façade of Orvieto Cathedral, possibly by Lorenzo Maitani; probably shortly before 1310. Opera del Duomo, Orvieto

55 Story of Dives and Lazarus (roundel) and masons (quatrefoil), detail of a stained-glass window given by the masons in Bourges Cathedral; *c.* 1220. Photo Scala

56 Interior of the north transept of Chartres Cathedral, looking east; 1194–1220. Photo Martin Hürlimann

57 Choir of Beauvais Cathedral; after 1284. Photo Martin Hürlimann

58 Choir of Canterbury Cathedral; between 1179 and 1184. Photo Martin Hürlimann

59 Nave of Canterbury Cathedral; begun 1373. Photo Walter Scott

60 Copies of figures by Giovanni Pisano on Siena Cathedral façade (originals now in the Opera del Duomo, Siena); c. 1290. Photo I. Bessi

61 Siena Cathedral façade; begun probably 1284–85, upper part completed after 1376. Photo Mansell-Alinari

62 Last Judgment, panel of reliefs by Lorenzo Maitani on the façade of Orvieto Cathedral; probably 1325–30. Photo Mansell-Anderson

63 West façade of Orvieto Cathedral; begun 1310. Photo Scala

64 Some of the statues of the Presentation in the Temple group, detail of the centre portal, west façade, Rheims Cathedral; c. 1236–40. Photo Martin Hürlimann

65 Hermann and Reglind, statues from the west choir of Naumburg Cathedral; begun 1249. Photo Helga Schmidt-Glassner

66 Interior of the Pazzi Chapel, Sta Croce, Florence, by Brunelleschi; c. 1440–61. Photo Scala

67 Self-portrait of the artist, detail of the bronze east door of Florence Baptistery by Lorenzo Ghiberti; 1425–37. Photo Mansell-Alinari

68 Gislebertus's signature under Christ's feet, on the lintel over the west doorway of Saint-Lazare, Autun; c. 1130. Photo Franceschi

69 Profile of Leonbattista Alberti on the obverse of a bronze coin by Matteo de' Pasti; Veronese, fifteenth century. Photo Victoria and Albert Museum, London

70 Portrait of Baldassare Castiglione by Raphael; probably recorded in a letter of 1516. Louvre, Paris. Photo Archives Photographiques, Paris

71 Creation of Adam and Eve, and the Fall, detail of a relief by Wiligelmo on the façade of Modena Cathedral; c. 1099–1106. Photo Cav. Uff. U. Orlandini

72 Pisa Cathedral pulpit, by Giovanni Pisano; 1302–10. Photo Mansell-Alinari

73 Habakkuk, called *Zuccone*, by Donatello, in niche on Florence Campanile (now in the Opera del Duomo, Florence); 1423–25. Photo Mansell-Alinari

74 Daniel and Isaiah, detail of the Moses Fountain by Claus Sluter made for the Chartreuse de Champmol near Dijon; 1395–1403. Musée de Dijon. Photo Werner Neumeister

75 Jeremiah, miniature attributed to André Beauneveu in a Psalter; c. 1401–03. MS. fr. 13091, f. 7v. Bibliothèque Nationale, Paris

76 Detail of the effigy of Charles V by André Beauneveu; 1364. Saint-Denis Abbey near Paris. Photo Archives Photographiques, Paris

77 Peacocks, a rook and other birds, page from a sketchbook; English, c. 1400. MS. 1916, f. 13. Pepysian Library. Reproduced by permission of the Master and Fellows of Magdalene College, Cambridge

78 Dogs attacking a boar, drawing from the sketchbook of Giovannino de' Grassi; Italian, c. 1380–90. Biblioteca Civica, Bergamo

79 Dogs attacking a boar, detail of the Calendar page for December, miniature by the Limbourg brothers in the *Très Riches Heures du duc de Berry*; French, 1413–16. MS. 65. Musée Condé, Chantilly. Photo Giraudon

80 Studies of a horse's head, double-page drawing by Antonio Pisanello from the *Vallardi Codex*; Italian, mid fifteenth century. Louvre, Paris. Photo Archives Photographiques, Paris

81 Men hoisting a sail, drawing from the sketchbook of Giovannino de' Grassi; Italian, c. 1380–90. Biblioteca Civica, Bergamo. Photo Wells

82 Angel of the Annunciation and interior of a room, detail of the *Merode Altarpiece* (centre panel) by the Master of Flémalle (Robert Campin); c. 1425–28. The Metropolitan Museum of Art, New York, The Cloisters Collection

83 Hildebert the illuminator (throwing something at a mouse) and his apprentice Everwinus, miniature from St Augustine's *De civitate*

Dei; German, twelfth century. MS. Kap. A. XXI, f. 133. Cathedral Chapter Library, Prague Castle

84 Procession against the plague in Rome led by Pope Gregory the Great, bas-de-page drawing, thought to be by the Limbourg brothers from a Book of Hours; French, early fifteenth century. MS. Douce 144, f. 110. Curators of the Bodleian Library, Oxford

85 Zeuxis the painter in his studio, miniature from Cicero's *Rhetoric*; Flemish, late fifteenth century. MS. 10, f. 69v. Bibliotheek der Universiteet, Ghent

86 Christ Pantocrator, mosaic in the apse of Cefalù Cathedral; Italian, twelfth century. Photo Mansell-Alinari

87 Christ in Judgment, detail of the Last Judgment tympanum of Autun Cathedral by Gislebertus; French, c. 1130. Photo Jean Roubier

88 Hell, detail of the Last Judgment (*Beaune Altarpiece*) by Roger van der Weyden; c. 1446–48. Hôtel-Dieu, Beaune. Photo Bulloz

89 Crucifixion, detail of the *Isenheim Altarpiece* (centre panel) by Matthias Grünewald; c. 1510. Musée Unterlinden, Colmar. Photo Giraudon

90 Madonna and Child with Saints John the Baptist and the Evangelist by Hans Memlinc; 1479. Hospital of St John, Bruges. Photo ACL

Index